Sampler Book 1, Ontario in Colour Photos, Saving Our History One Photo at a Time

Photography by Barbara Raué

Series Name: Cruising Ontario

Sampling from several towns

Each photo I take that precedes a demolition, or a natural disaster such as a tornado or a fire, is meeting this aim of mine of Saving Our History One Photo at a Time. There are more than 100 towns already photographed which you can visit without moving from your comfortable chair in your living room. Dream about what it was like in those by-gone days. Dream about what it was like to live in a mansion like one of these. Where would you like to travel to next?

Cover: 26 Lansdowne Road North, Galt, Ontario

Table of Contents

Top 6 Architectural Styles in Ontario

Top 4 Roof Styles in Ontario Architecture

Dundas, Ontario – My Top 6 Picks

London, Ontario – My Top 6 Picks

Hamilton, Ontario – My Top 6 Picks

Oakville, Ontario – My Top 6 Picks

Waterford, Ontario – My Top 6 Picks

Owen Sound, Ontario – My Top 6 Picks

Mount Forest, Ontario – My Top 5 Picks

Ancaster, Ontario – My Top 6 Picks

Brantford, Ontario – My Top 5 Picks

Burlington, Ontario – My Top 5 Picks

Guelph, Ontario – My Top 7 Picks

Ayr, Ontario – My Best 5 Picks

Peterborough, Ontario – My Top 7 Picks

Orangeville, Ontario – My Top 6 Picks

Southampton, Ontario – My Top 6 Picks

Top 6 Architectural Styles in Ontario

Edwardian

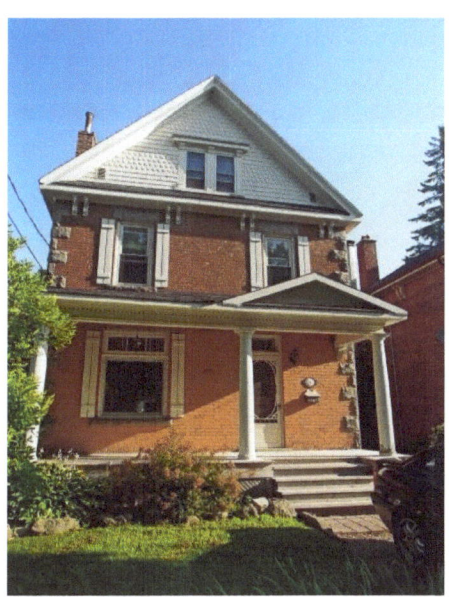

6 York Street, Orangeville, Ontario
- simple, balanced facades
- simple rooflines
- dormer windows
- large front porches
- smooth brick surfaces
- voussoirs and keystones are used sparingly and are understated
- finials and cresting are absent
- cornice brackets and braces are block-like
- openings have flat arches or plain stone lintels

Georgian

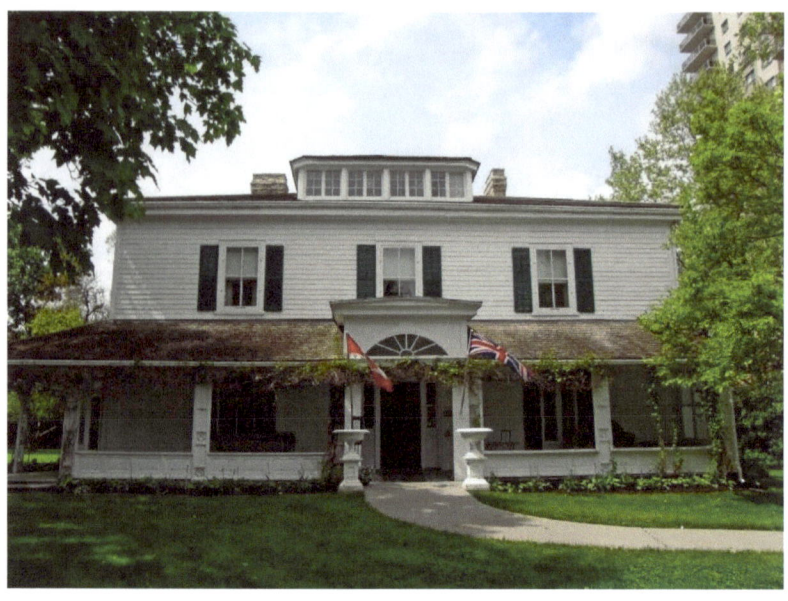

481 Ridout Street, London, Ontario
- balanced facades around a central door
- medium-pitched gable roofs
- small-paned windows

Gothic

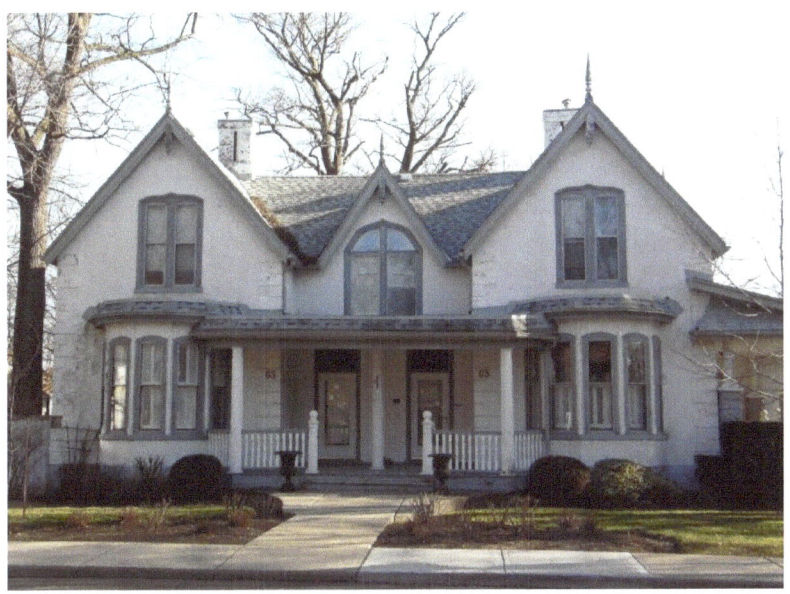

63-65 Sydenham Street, Dundas, Ontario
- decorative buildings with sharply-pitched gables
- highly detailed verge boards
- pointed-arch window openings
- dichromatic brickwork

Italianate

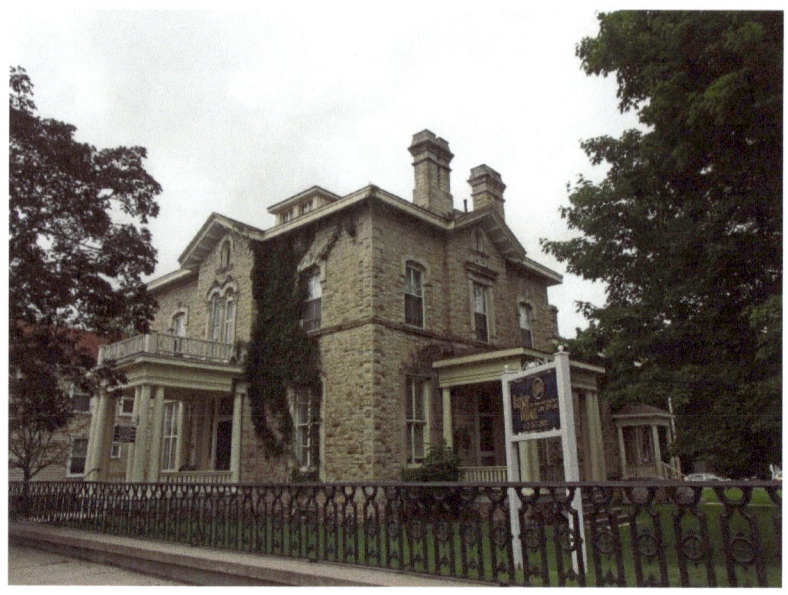

31 Foster Street, Perth, Ontario
- two story rectangular buildings
- hip roof
- a projecting frontispiece
- generous eaves with ornate cornice brackets
- large sash windows
- quoins
- ornate detailing on the windows
- belvederes
- wraparound verandahs
- cast iron cresting
- elegant window surrounds

Queen Anne

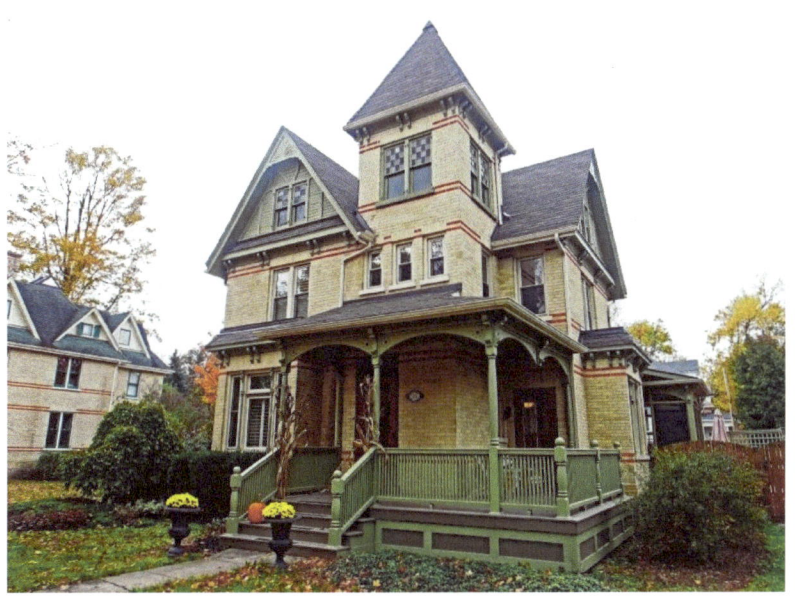

26 Lansdowne Road North, Galt, Ontario
- irregular outline
- an offset tower
- broad gables
- projecting two-storey bays
- verandahs
- multi-sloped roofs
- tall, decorative chimneys
- a mixture of brick and wood is common

Second Empire

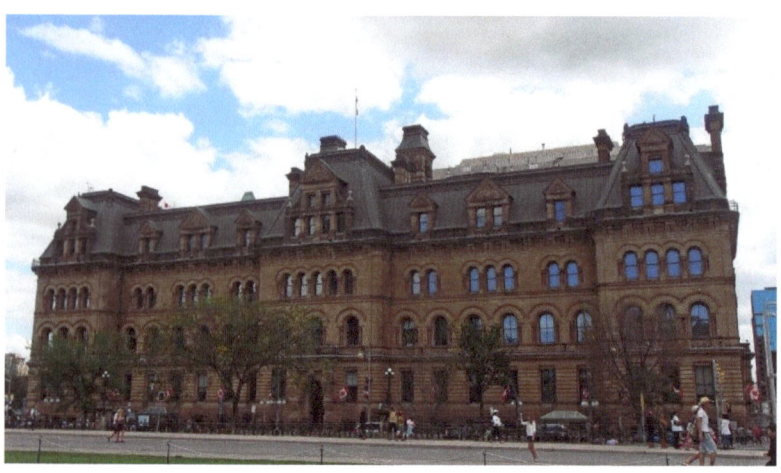

Langevin Block, Wellington Street, Ottawa, Ontario
- mansard roof
- projecting central towers
- one or two-storey bays

Top 4 Roof Styles in Ontario Architecture

Gable Roof

13 Lake Avenue, Stoney Creek
- the triangular portion of a wall between the edges of a sloping roof
- Jacobean Gable: the gable extends above the roofline

Gambrel Roof

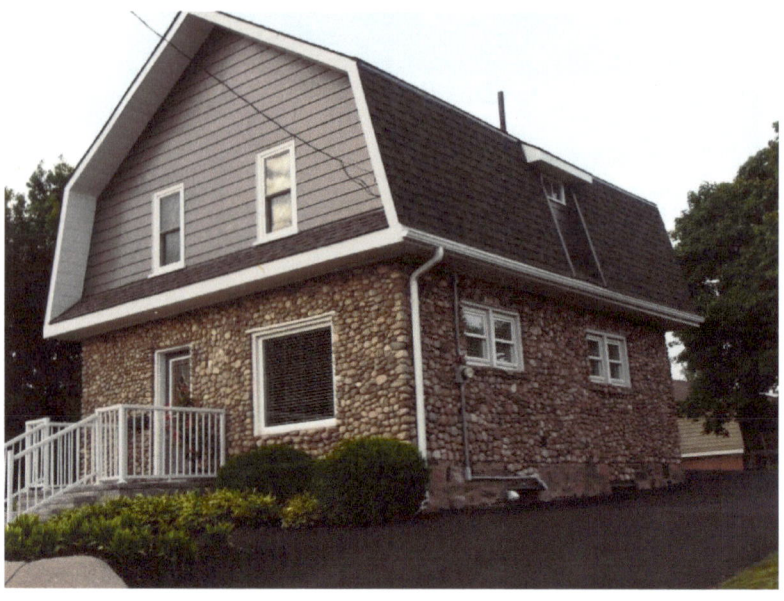

King Street, Midland
- a symmetrical two-sided roof with two slopes on each side
- the upper slope is positioned at a shallow angle, while the lower slope is steep
- has vertical gable ends instead of being hipped at the four corners of the building

Hipped Roof

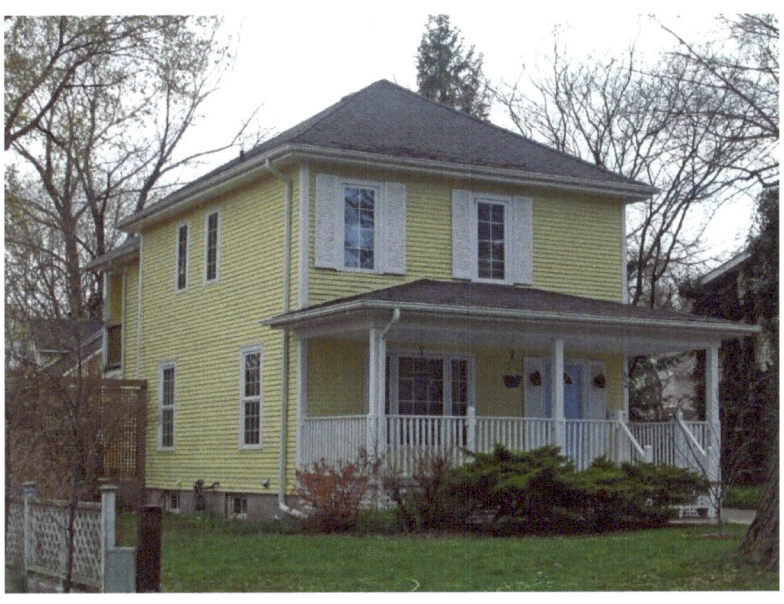

52 Burnet Street, Oakville
- all sides slope downwards to the walls with no gables

Mansard Roof

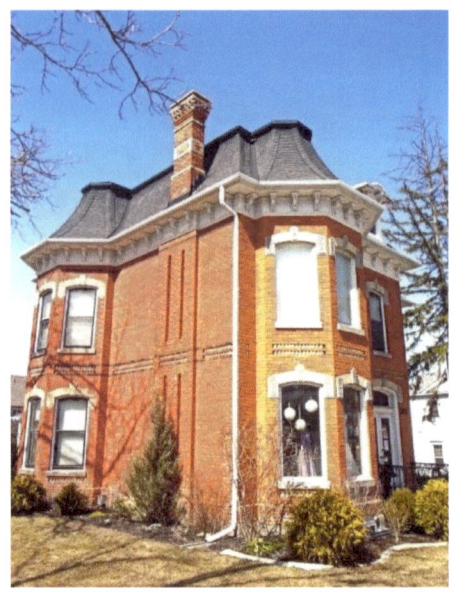

299 Dundas Street, Waterdown

This style was popularized by Francois Mansart (1598-1666), an accomplished architect of the French Baroque period and especially fashionable during the Second French Empire (1852-1870).
- This roof is almost flat on the top section, with two slopes on each of its sides with the lower slope at a steeper angle than the upper
- has dormer windows

Dundas, Ontario – My Top 6 Picks

Collins Hotel – Classical Revival style – Book 1

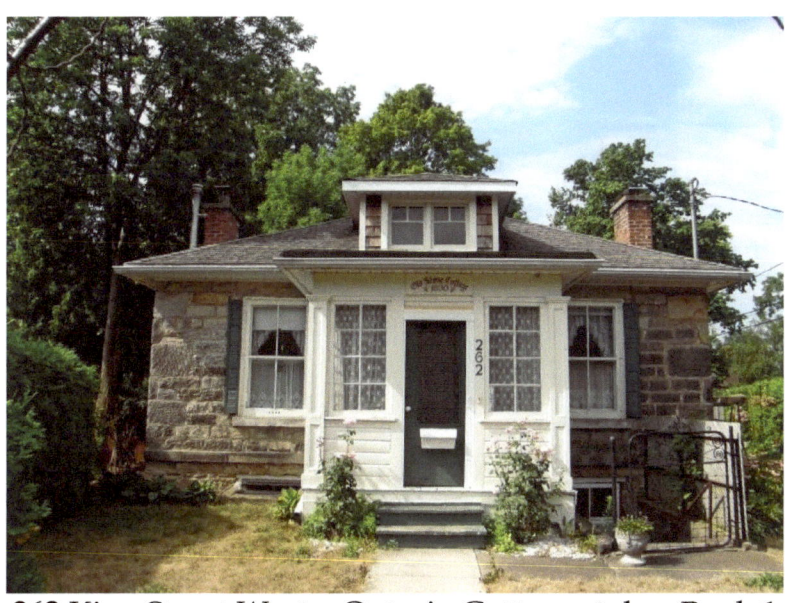

262 King Street West – Ontario Cottage style – Book 1

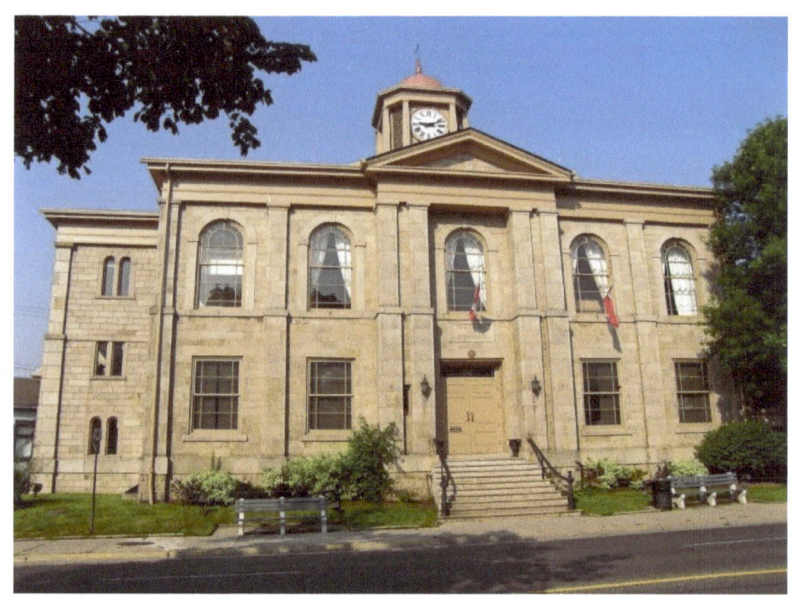

Dundas Town Hall - Renaissance Revival style – Book 1

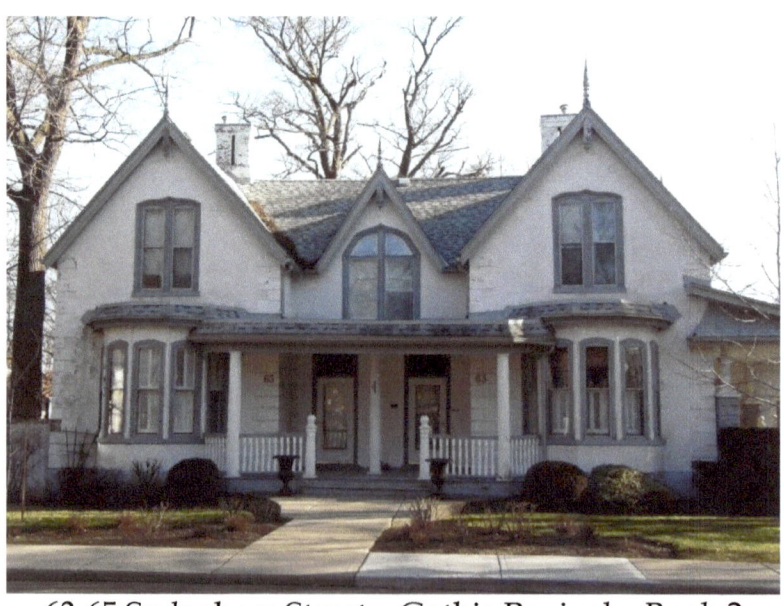

63-65 Sydenham Street – Gothic Revival – Book 2

Victoria Street – Italianate style – Book 3

Cross Street – Second Empire style – Book 3

London, Ontario – My Top 6 Picks

London was the first city in Ontario where I photographed the old buildings. Why did I choose London? My girlfriend moved from Stoney Creek to London and I saw some of the old buildings when I visited Linda. I decided it was a good place to start my photography. London is located in southwestern Ontario on the Thames River.

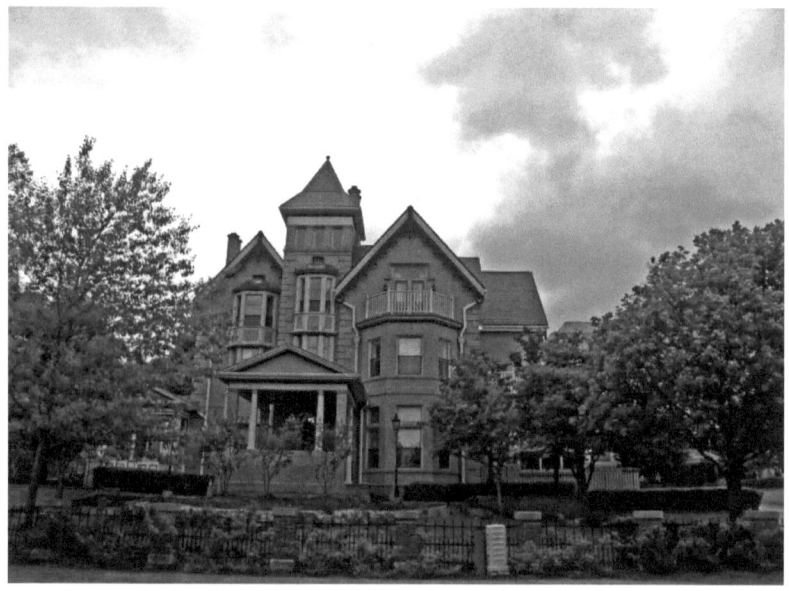

Queen Anne style

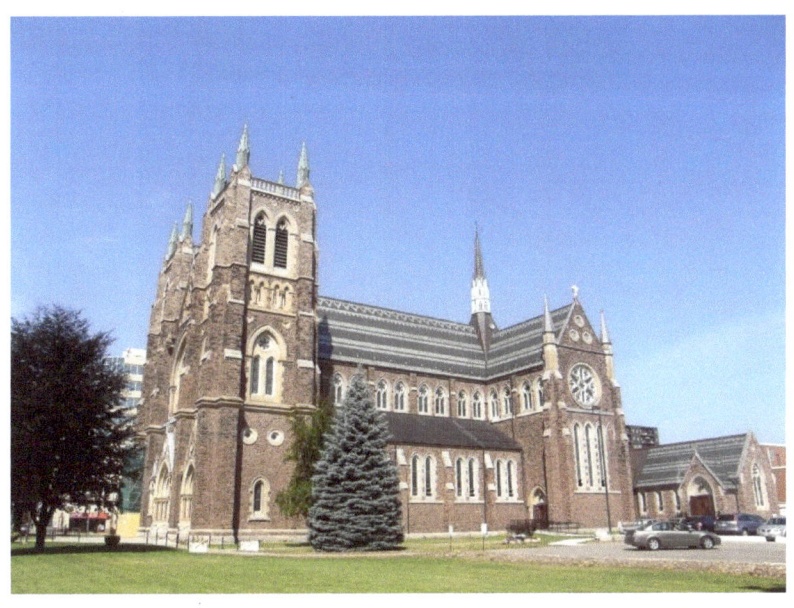

St. Peter's Cathedral Basilica, begun in 1880 and dedicated in 1885, is in the 13th Century French Gothic style. Some of its notable features are the massive bell towers, high transepts, an imposing sanctuary, and the rose window built in Innsbruck, Austria.

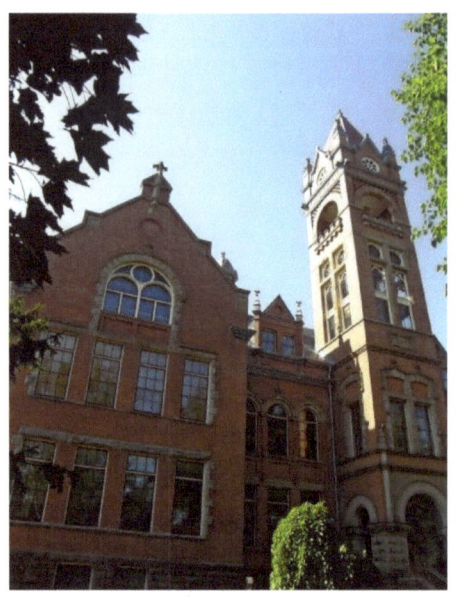

The Normal School, 165 Elmwood Avenue East - This 3 storey building was designed in the High Victorian style in 1898-1899. The London Normal School provided teacher training until 1956.

Brescia Residence, University of Western Ontario – Nuns lived in the left portion, students in the right; as the nuns died and no new ones took their places, the remainder of the building became residences for students.

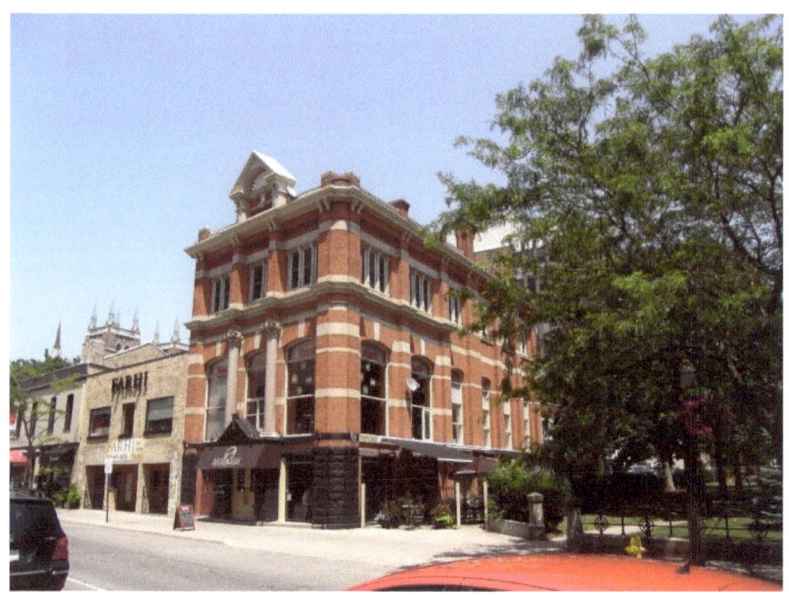

Downtown - Dichromatic brickwork, decorative capitals on pillars, cornice brackets

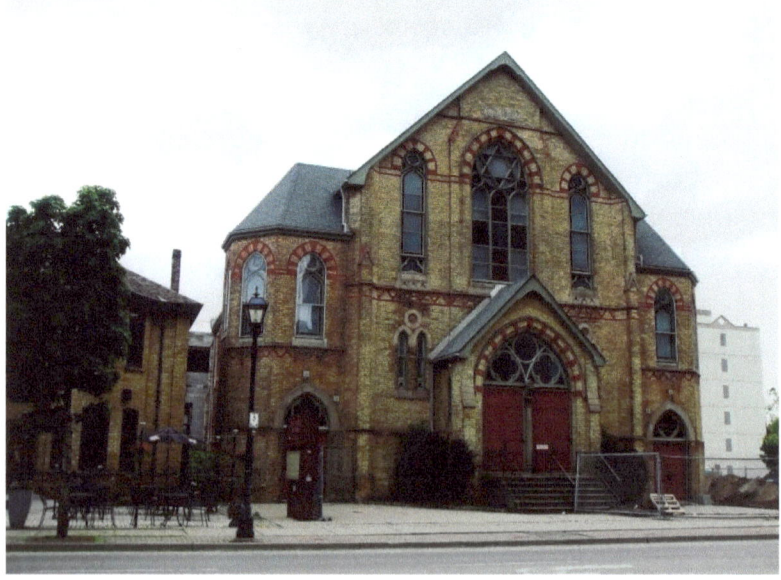

Talbot Street Baptist Church erected in 1881. It is now a Christian Reformed Church.

Hamilton, Ontario – My Top 6 Picks

Hamilton, the center of a densely populated and industrialized region, is located in Southern Ontario on the western part of Lake Ontario. Hamilton Harbour marks the northern limit of the city, and the Niagara Escarpment runs through the middle of the city bisecting it into "upper" and "lower" parts. There are over one hundred waterfalls and cascades within the city, most of which are on or near the Bruce Trail as it winds through the Niagara Escarpment.

Two steel manufacturing companies, Stelco and Dofasco, were formed in 1910 and 1912, and Procter & Gamble opened a manufacturing plant in 1914. McMaster University moved from Toronto to Hamilton, an airport was built in 1940, a Studebaker assembly line started in 1948, the Burlington Bay Skyway Bridge was built in 1958, and the first Tim Horton's store opened in 1964.

On January 1, 2001, the new City of Hamilton was formed through the amalgamation of the former city and the six municipalities of Stoney Creek, Glanbrook, Ancaster, Dundas, and Flamborough. We have lived in Hamilton for more than 40 years; it is here that we raised our three children.

235 Locke Street North - Castle Doune – Regency Style - Hamilton Book 1

Sir Allan MacNab hired Robert Wetherell to design his Regency residence between 1835 and 1840. Castle Doune, once called St. Mary's Lodge, was a Gate Lodge for the superintendent of Dundurn. The house was enlarged in 1908 with the turret and rounded bay on the southern half. The chimney and windows are features of Dundurn Castle.

90 Stinson Street – Fearman House – 1863 – Gothic style - Hamilton Book 3

Frederick William Fearman was the son of a shoemaker who emigrated from England in 1833 with his parents at the age of eight. He started his business with a store selling smoked and salted meats on Hughson Street between King and King William, moved to a MacNab Street North location near the farmers' market, and eventually expanded to become W. Fearman Packing Company Limited, with a large factory at Rebecca Street and Ferguson Avenue on the Grand Trunk Railway line. The company slaughtered, hung, salted, smoked and canned pork, beef, veal and lamb for shipment around the world. Fearman built his mansion, "Ivey Lodge", at 90 Stinson Street in 1863. It is three-storey, limestone block with a Mansard-roofed tower as its front entrance; it has bay and arched windows, dormers, verge board trim, and a green metal roof. Fearman used his influence to help establish Hamilton as a major center in Canada's early days. He was a philanthropist who fought for the city's first waterworks in 1855 and led the fight to buy Dundurn Castle and park to save it from land developers.

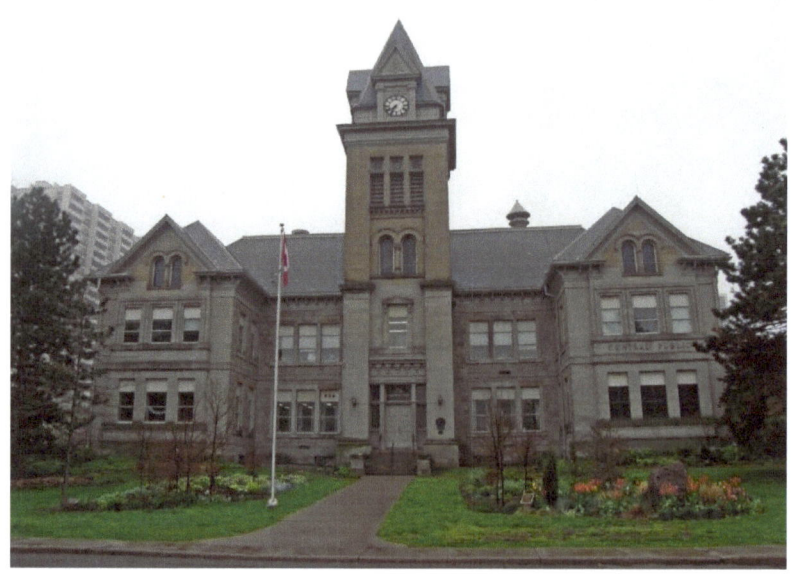

Hunter Street West - Hamilton Central Public School – Classical Style - Hamilton Book 2

It was built to accommodate 1,000 students, was the largest graded school in Upper Canada and was the only public school in Hamilton when it opened in 1853. The building's original finely proportioned Classical style was extensively remodeled in 1890 with a steeply pitched roof, round-arched windows and a higher central tower to conform to late Victorian tastes.

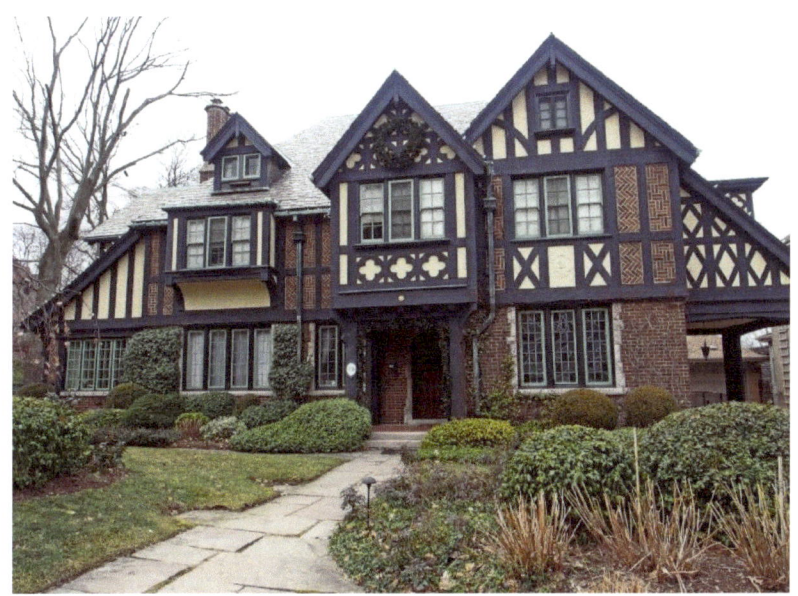

358 Bay Street South - Tudor Revival style – Hamilton Book 4

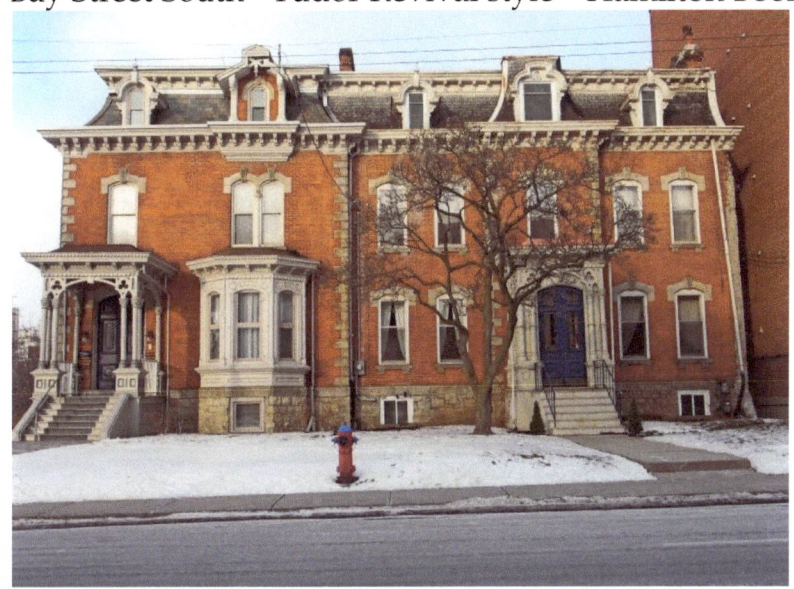

46 Herkimer Street – Second Empire – Hamilton Book 5
It has a mansard roof, dormers with decorative window hoods, entrance ways, bay windows, corner quoins, cornice brackets.

Oakville, Ontario – My Top 6 Picks

Oakville is situated on Lake Ontario in southern Ontario. In 1793, Dundas Street was surveyed for a military road. By 1807, British immigrants settled the area around Dundas Street and on the shores of Lake Ontario.

In 1827, George Chalmers built a settlement with water-powered mills beside the Sixteen at the Dundas crossing. A small sawmill and gristmill were constructed on the valley bottom at the edge of a pond formed by a dam. In future years, a church, school, ashery, blacksmith shop, distillery, and tavern provided services to the local farmers. The village continued to prosper with the addition of a tannery, carding mill and steam stave mill until the coming of the railroad to Oakville in 1855.

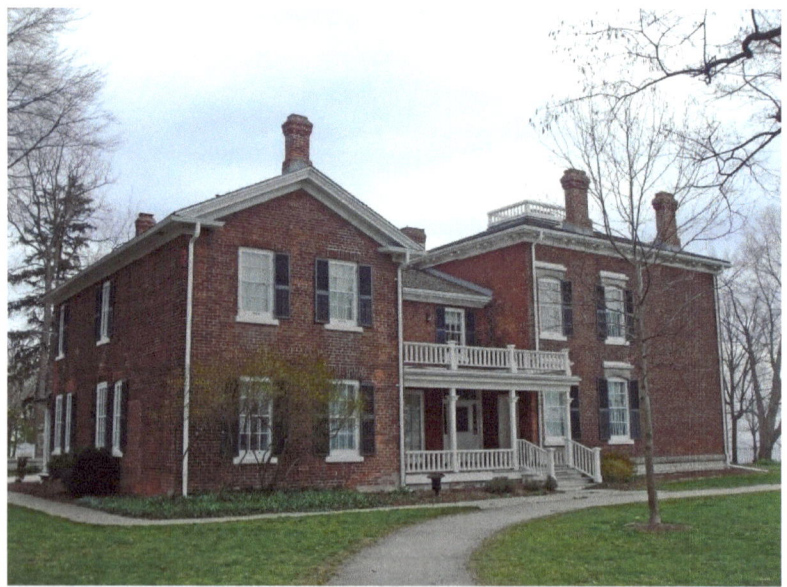

Erchless built in 1858 by Robert Kerr Chisholm on the east bank of the harbor mouth – now part of the Oakville Museum

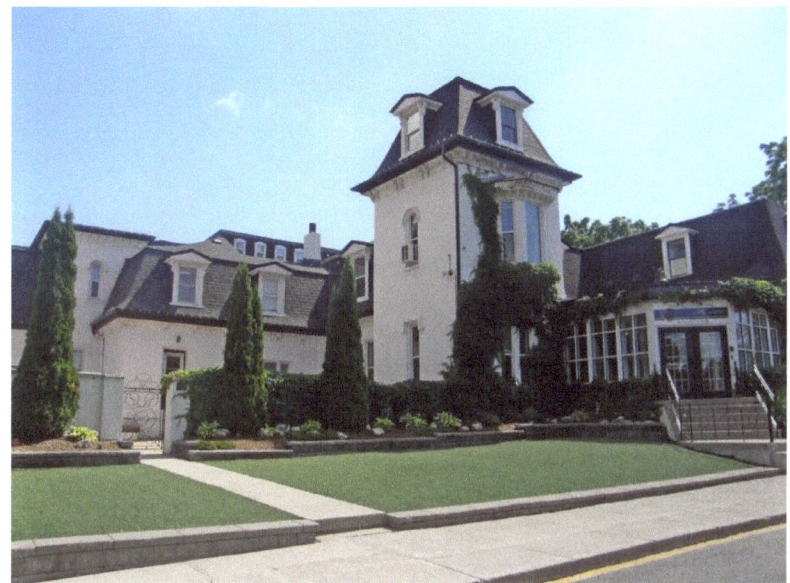

337 Trafalgar Road - MacLachlan College - Second Empire style – mansard roof, dormers

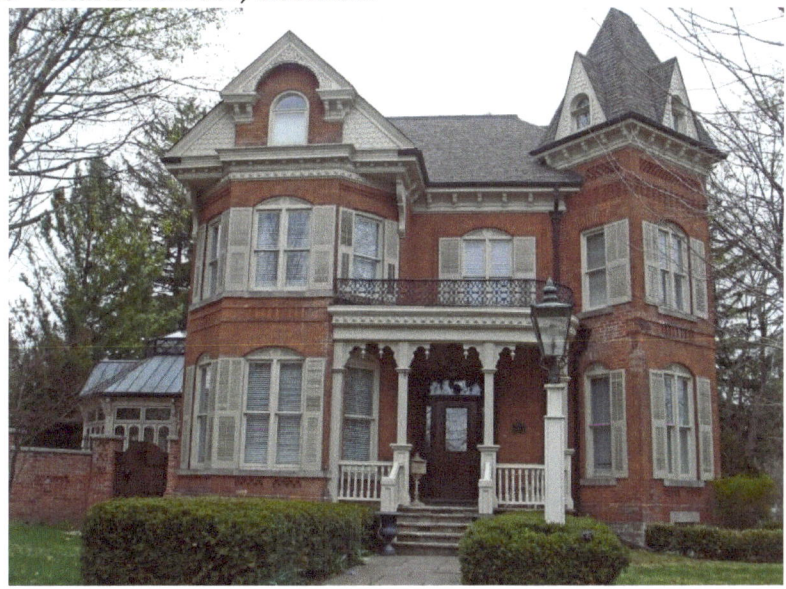

43 Dunn Street - Cecil Marlatt's estate – Queen Anne style, towers, bay windows, balcony on second floor, cornice brackets

235 Randall Street – Second Empire - mansard roof, dormers

Downtown Oakville – Second Empire style

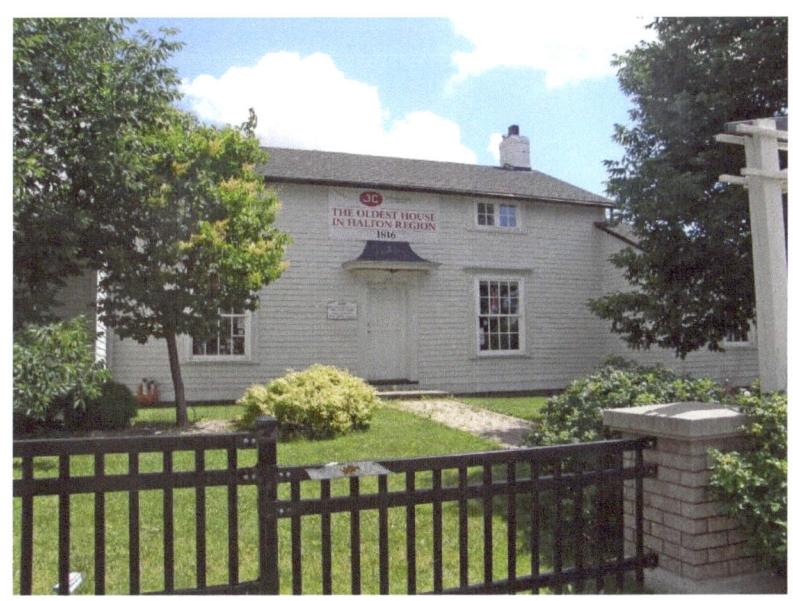

1816 – oldest house in Halton Region - Amos Biggar, United Empire Loyalist; original Location: 502 Dundas Street West - Classic Revival style; now The Cork House - 2441 Neyagawa Boulevard

Waterford, Ontario – My Top 6 Picks

Waterford is located on Pleasant Ridge Road, or old Highway 24 in Norfolk County, south of Brantford, north of Simcoe and southwest of Ohsweken. Waterford was established in 1794 with saw and grist mills on Nanticoke Creek. An early industry was the agricultural implement factory built by James Green, a local merchant. The area surrounding the town is primarily agricultural land with tomatoes, tobacco and corn among the main crops.

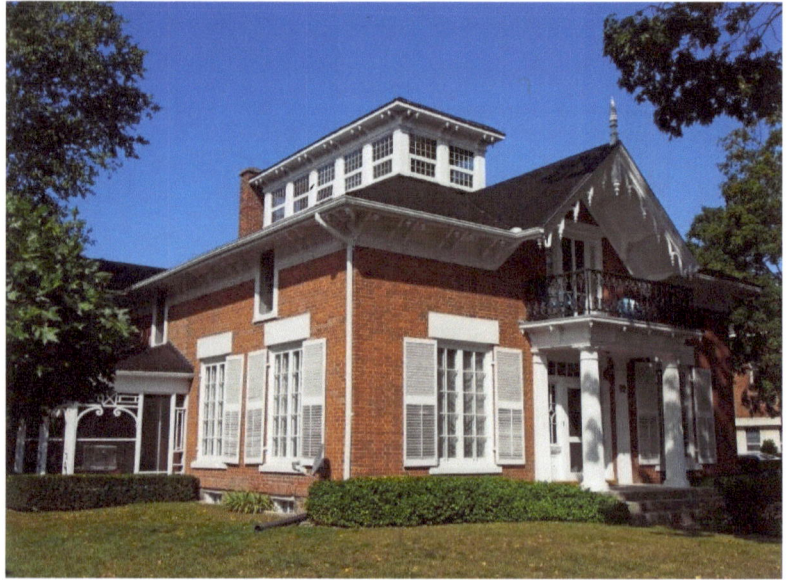

92 Main Street – Italianate, belvedere on roof, paired cornice brackets, verge board and finial on gables, second floor balcony, Doric columns

Neo-colonial style of architecture with a gambrel roof

163 Main Street – Vernacular – three storey tower, intricate spindle woodwork on porch, pediments, unusual shaped turret or tower

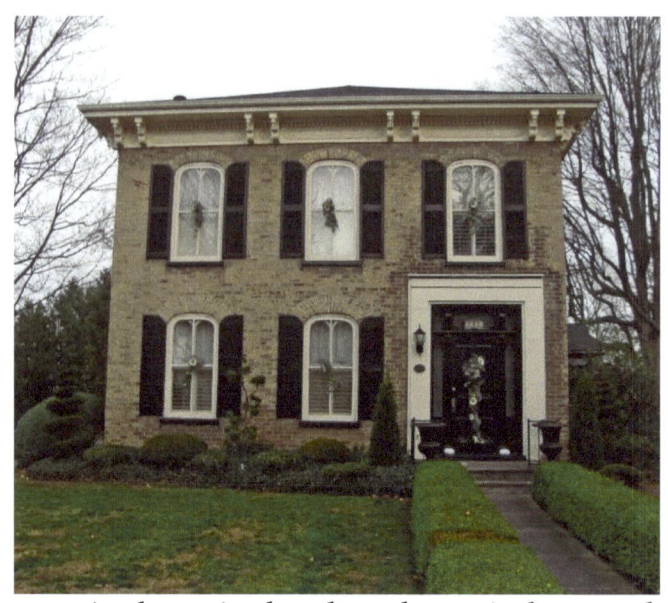

Italianate – paired cornice brackets, bay window on the side of the house

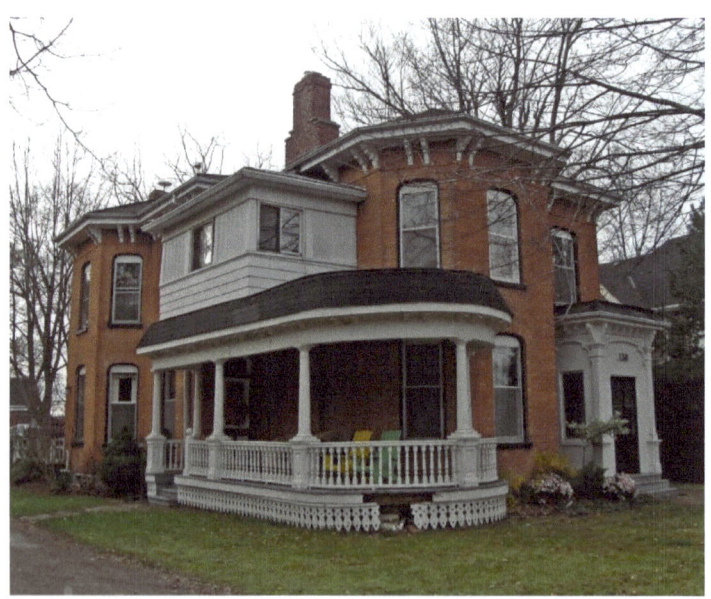

138 Main Street – Italianate, paired cornice brackets, wraparound verandah

Georgian – six-over-six windows, Doric pillars, widow's walk on top of hipped roof, two tall chimneys, sidelights and transom window around door

Owen Sound, Ontario – My Top 6 Picks

Owen Sound is located on the southern shores of Georgian Bay in a valley below the sheer rock cliffs of the Niagara Escarpment. The city is located at the mouths of the Pottawatomi and Sydenham Rivers. It has tree-lined streets, many parks, and tree-covered hillsides and ravines. There are two photo books on Owen Sound if you want to see more.

In 1848, John, William and Robert Harrison arrived in the Village of Sydenham (now Owen Sound). They operated waterpower grist, woolen and saw mills. In 1861 John married Emma Hart and they raised their family of six children in a house beside his mills. In 1875-76 they purchased the land now known as Harrison Park where they built roads, bridges, paths and buildings, gradually bringing his vision for the parkland to life.

The park today has picnic facilities, basketball courts, heated twin swimming pools, canoe and paddle boat rentals for use on the river, a bird sanctuary, a mini-putt golf course, playground, campsites, cycling and walking trails, and the black history cairn and Freedom Trail.

1000 First Avenue West – Queen Anne Revival style, built in 1893-94 – turret, Palladian window – Owen Sound Book 1

Edwardian style – Owen Sound Book 1

932 3rd Avenue West - Former U.S. Consulate – 1890 – Vernacular example with Italianate influence, tower – Owen Sound Book 1

#629 – Gothic Revival, corner quoins – in Book 1 on Owen Sound

Tudor Revival – in Book 2 on Owen Sound

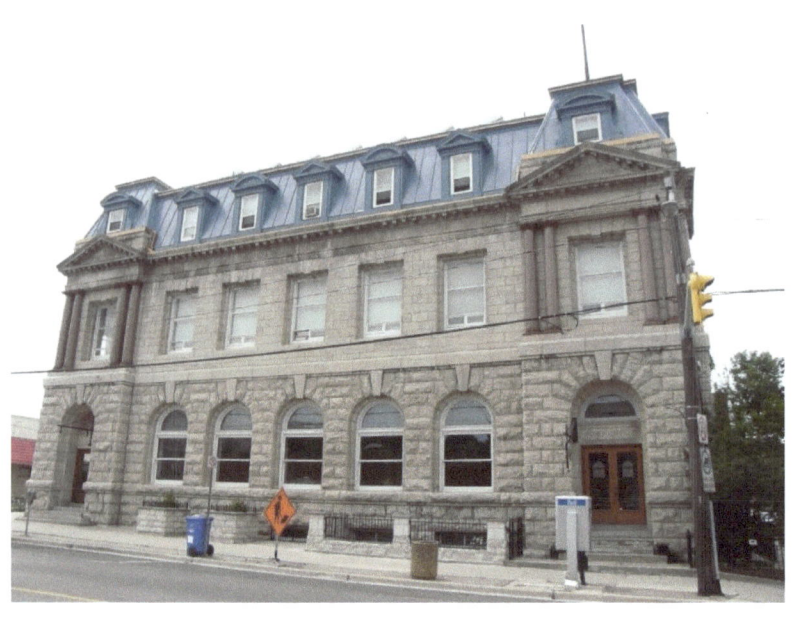

Old Post Office – 1907 – Beaux Arts style featuring harmony and balance; positioning of windows, Ionic columns, pediments project vertical and horizontal symmetry; shapes and materials echo across all three floors in pleasing proportions; varied texture of stone graduates from rough and solid rock face limestone to slightly inset and smoother stone above, providing a lighter feel the higher the building climbs; window sills are continuous cut stone, walls are lined with brick; a brick vault was constructed on each of the first and second floors; mansard roof with dormers; voussoirs and keystones over windows and doors on first floor – in Book 2 on Owen Sound

Mount Forest, Ontario – My Top 5 Picks

Mount Forest is located at the junction of Highways 6 and 89 on a height of land near the headwaters of the Saugeen River. In 1871, eighteen years after the town was surveyed, it had ten hotels, eight churches and eighteen stores; the first train came into Mount Forest later that year.

Prior to European settlement, present day Mount Forest was prime hunting ground for the Saugeen Ojibway peoples due to its location on the Saugeen River.

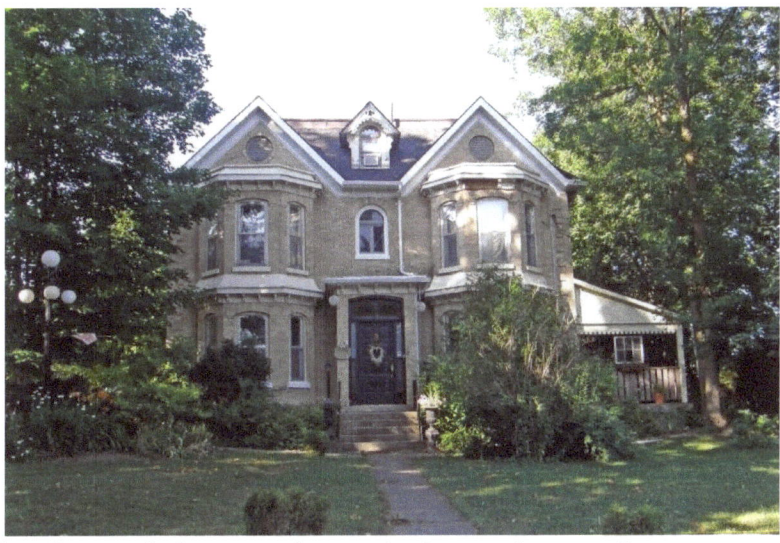

Gothic Revival, 2-storey bay windows, dormer between gables

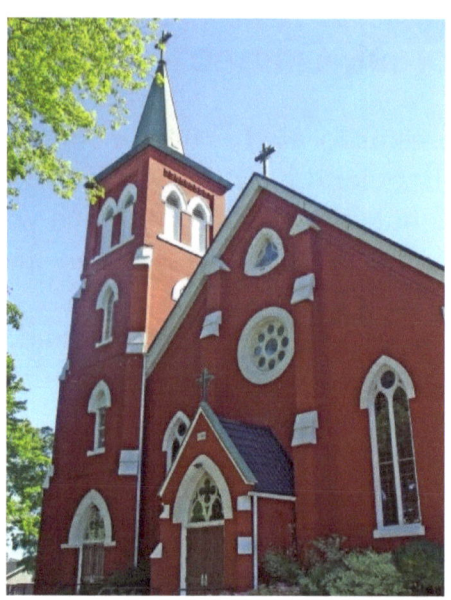

230 Queen Street East - St. Mary's Catholic Church - established 1863 – buttresses, lancet windows, dichromatic

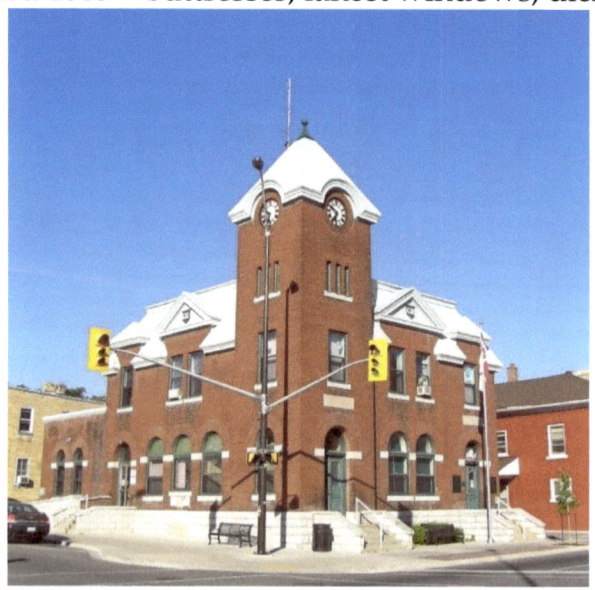

170 Wellington Street West - Mount Forest Post Office - built in 1912. The timepiece for the clock tower was made in Birmingham, England.

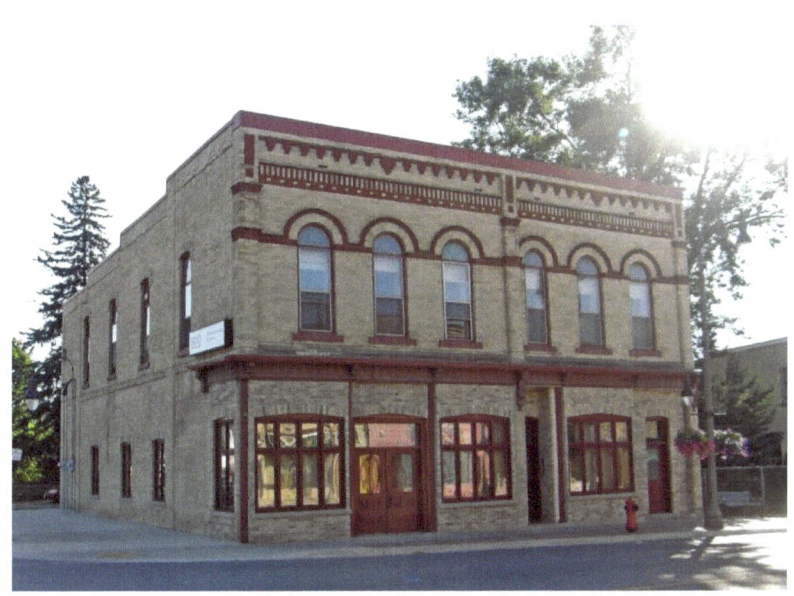

Dichromatic brickwork, beveled dentils, pilasters

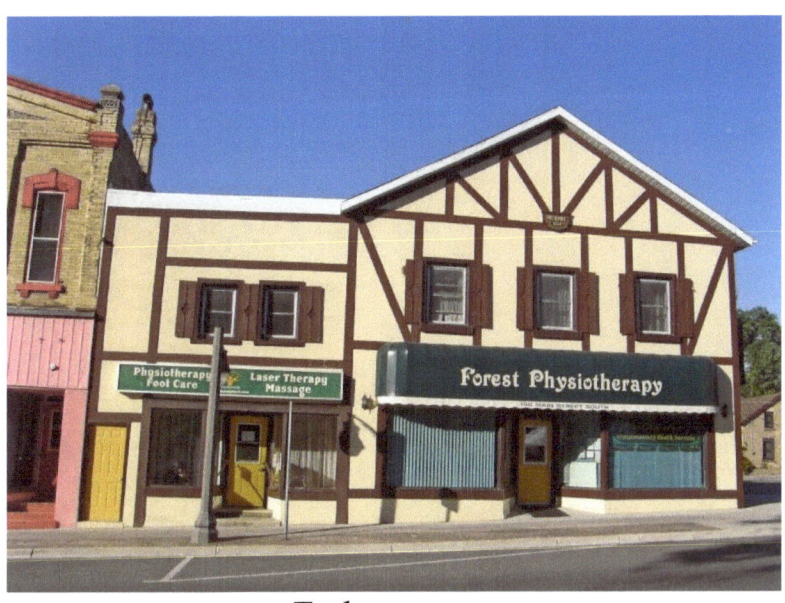

Tudor accents

Ancaster, Ontario – My Top 6 Picks

The earliest European settlers to arrive and clear land in the mid-18th century in what would eventually become Ancaster were made up of American farmers travelling north searching for arable land, French-speaking fur traders, and British immigrants. Also arriving into this area around 1787 with the incentive of inexpensive land grants were the United Empire Loyalists loyal to the British crown who were fleeing from the United States after the 1776 American War of Independence. Britain's promise of free land brought many people who did not exhibit the same loyalty to the crown as the Loyalists. This eventually led to a series of defections, accusations and treasonous acts during the War of 1812 that precipitated the largest mass hangings in Canadian history, the so-called Bloody Assizes whose trial took place in Ancaster in 1814.

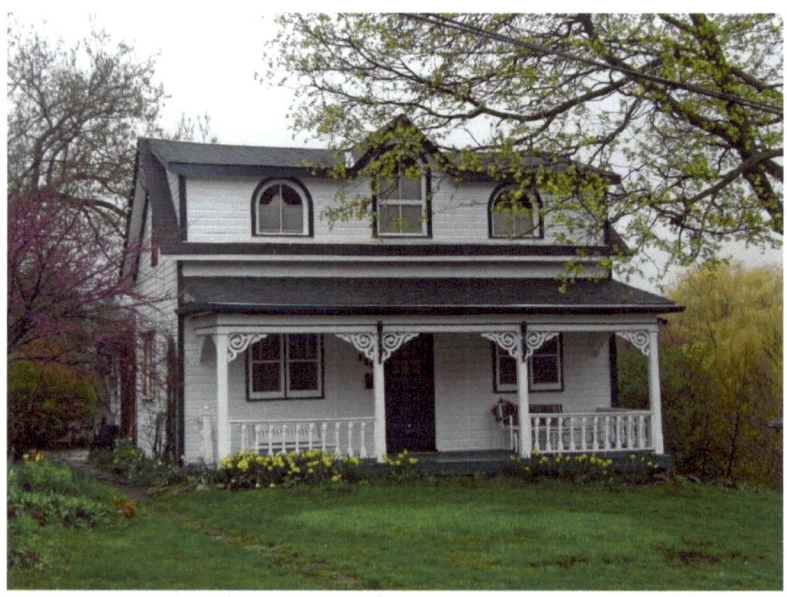

#535 - Gothic Revival style with centre gable

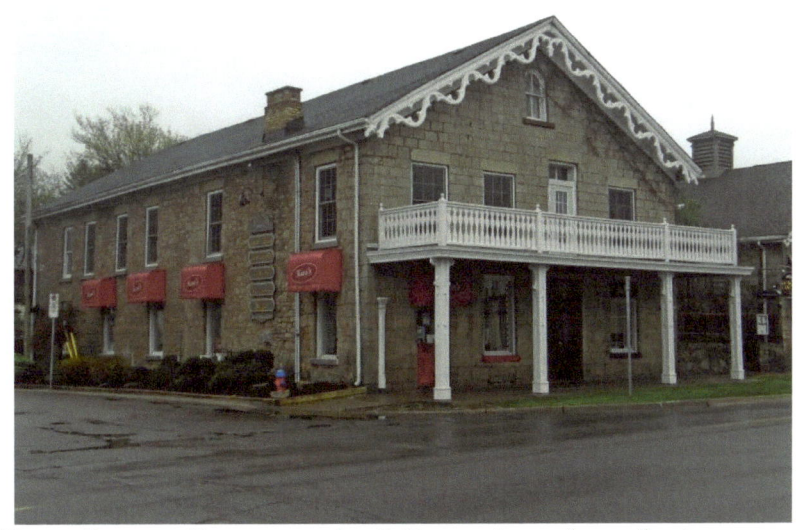

Wilson Street - limestone building, gingerbread trim, second floor verandah

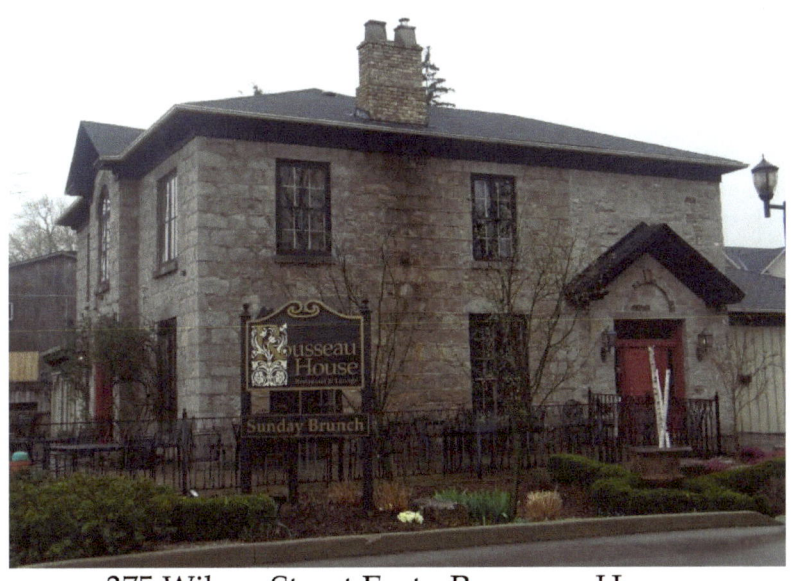

375 Wilson Street East - Rousseau House - built in 1838 by George Brock Rousseau, postmaster of Ancaster for ten years

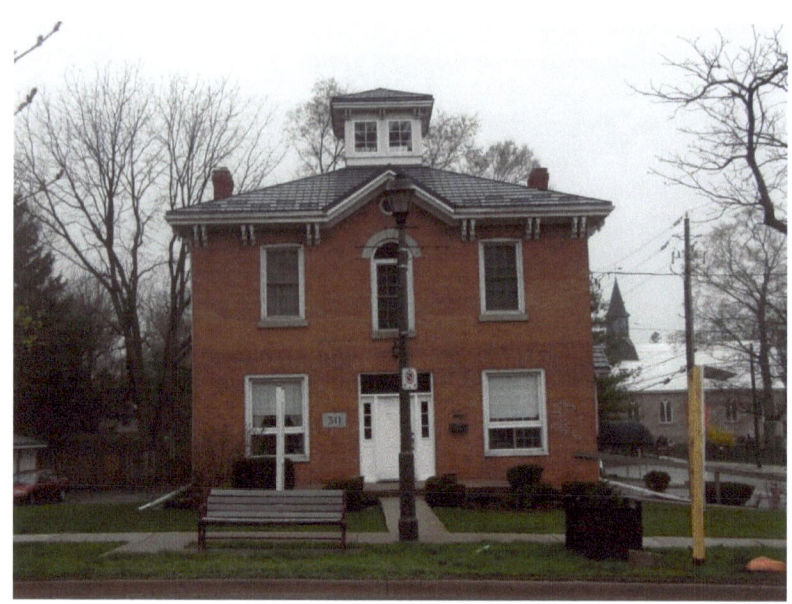

311 Wilson Street East – Italianate, belvedere, paired cornice brackets

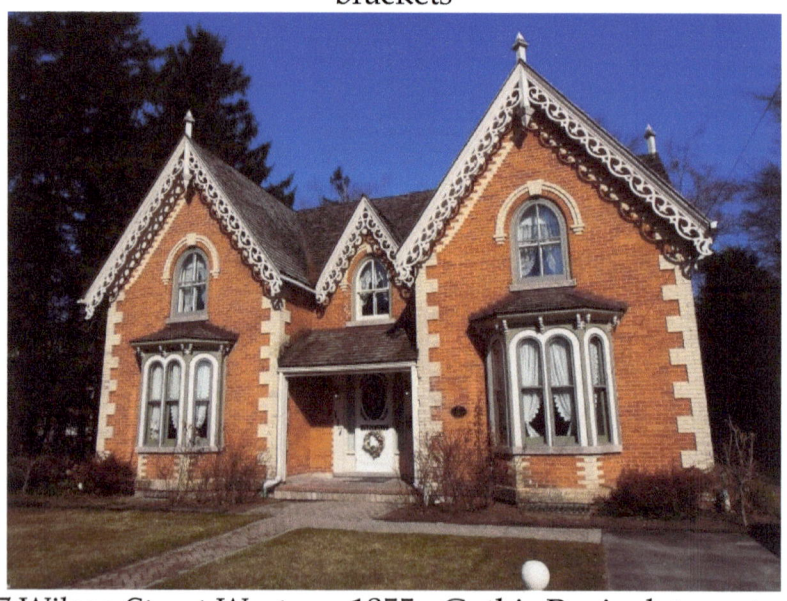

117 Wilson Street West – c. 1855 - Gothic Revival, two-storey red brick house, verge board trim and finials on gables, corner quoins, bay windows

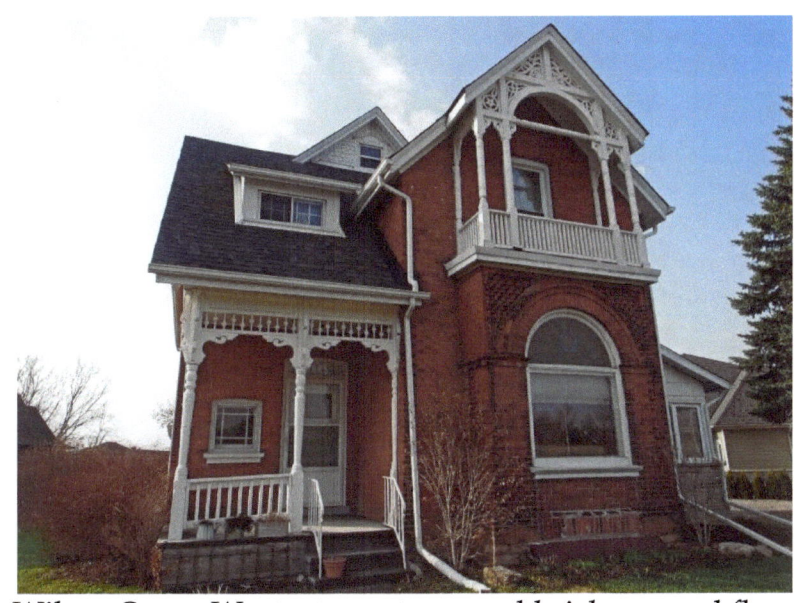

Wilson Street West – two-storey red brick, second floor balcony under gable which has stenciling on the verge board trim, dormer, bric-a-brac on lower porch

Brantford, Ontario – My Top 5 Picks

Brantford is located on the Grand River in Southern Ontario. Brantford is connected to Woodstock in the west and Hamilton in the east by Highway 403 and to Cambridge to the north and Simcoe to the south by Highway 24. Brantford is known by the nickname *The Telephone City* as former city resident Alexander Graham Bell conducted the first distant telephone call from the community to Paris, Ontario in 1876. It is also the birthplace of hockey player Wayne Gretzky.

In 1784, Captain Joseph Brant and the Six Nations Indians of the Iroquois Confederacy left New York State for Canada. As a reward for their loyalty to the British Crown, they were given a large land grant on the Grand River. The original Mohawk settlement was on the south edge of the present-day city at a location favorable for landing canoes. Brant's crossing of the river gave the original name to the area: Brant's ford. By 1847, European settlers began to settle further up the river at a ford in the Grand River and named their village Brantford. Brantford was incorporated as a city in 1877.

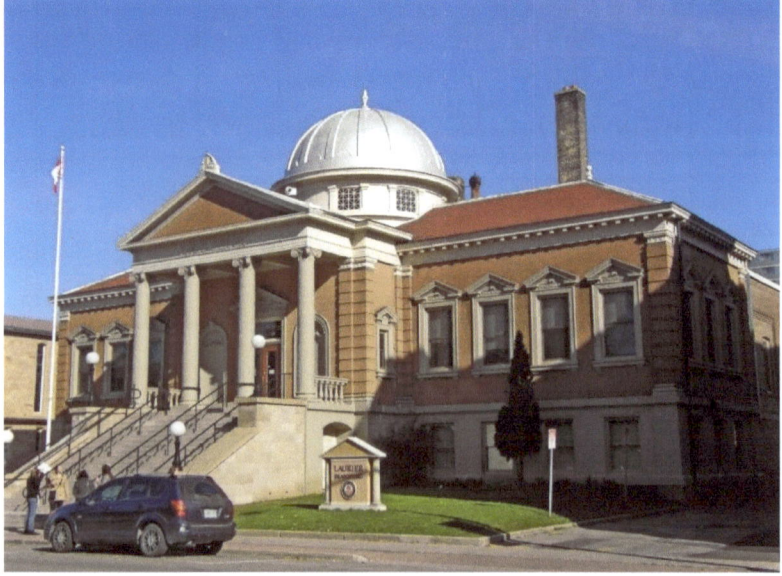

Laurier Brantford – Ionic capitals on pillars, pediment

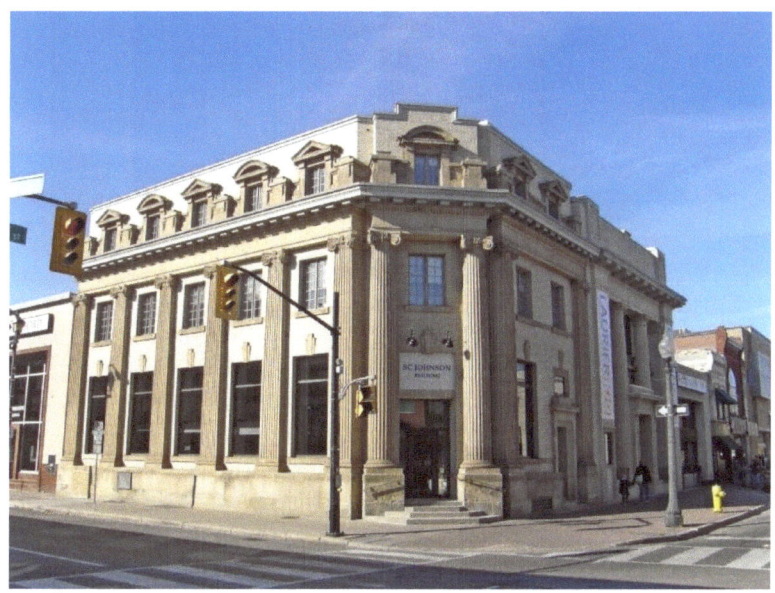

SC Johnson Building – corner Dalhousie & Market Streets, mansard roof with dormers with triangular window hoods

26 Lorne Crescent - Italianate - 1875 - dichromatic brickwork, paired cornice brackets, bay window on side

#30 - 1896 – Queen Anne style - round turret

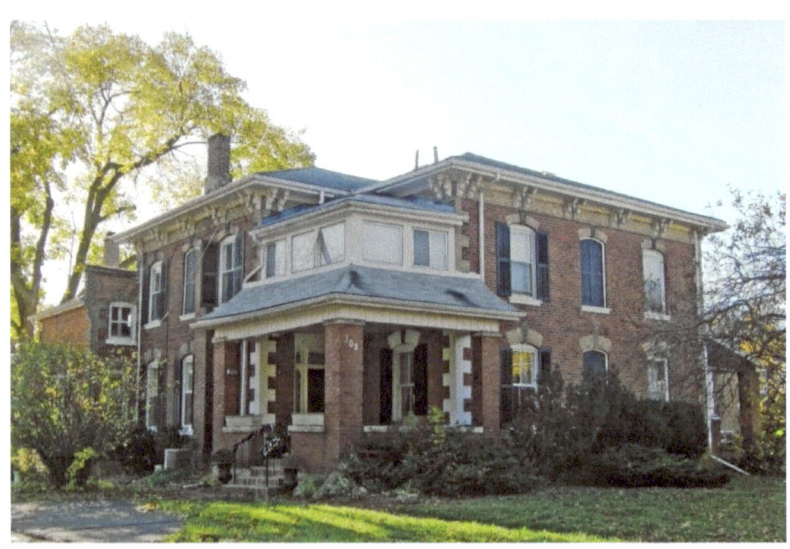

#102 – Italianate, hipped roof, paired cornice brackets, corner quoins

Burlington, Ontario – My Top 5 Picks

Burlington is located at the western end of Lake Ontario, lying between the north shore of the lake and the Niagara Escarpment, north of Hamilton. Before pioneer settlement in the 19th century, the area was covered by old-growth forest and was home to various First Nations peoples. In 1792, John Graves Simcoe, the first lieutenant governor of Upper Canada, named the western end of Lake Ontario "Burlington Bay" after the town of Bridlington in Yorkshire, England. Land beside the bay was deeded to First Nations Captain Joseph Brant at the turn of the nineteenth century. With the completion of the local survey after the War of 1812, the land was opened for settlement. Early farmers prospered because of the fertile soil and moderate temperatures. Lumber from the surrounding forests was a thriving business. In the latter half of the nineteenth century, local farmers switched to fruit and vegetable production. The first peaches grown in Canada were cultivated in the Grindstone Creek watershed in the south-west part of the city.

Hamilton Harbour, the western end of Lake Ontario, is bounded on its western shore by a large sandbar. A canal bisecting the sandbar allows ships access to Hamilton Harbour. The Burlington Bay James N. Allan Skyway, part of the Queen Elizabeth Way, and the Canal Lift Bridge allow access over the canal.

The leading industrial sectors are food processing, packaging, electronics, motor vehicle/transportation, business services, chemical/pharmaceutical and environmental.

Burlington is home to the Royal Botanical Gardens, which has the world's largest lilac collection.

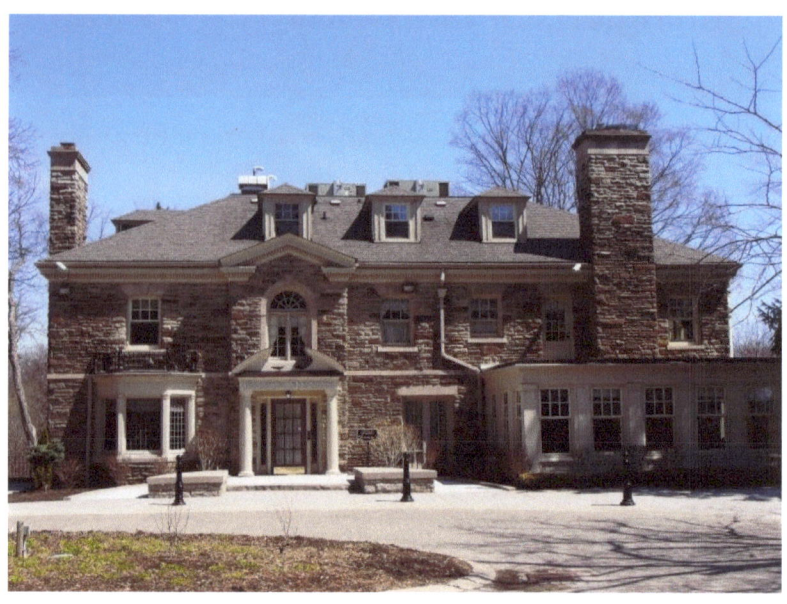

Paletta Mansion – In 1809, the British Crown, under King George III, granted Lot 8, Concession 4 South of Dundas Street to Laura Secord, who was later to distinguish herself as a heroine in the events of the Battle of Lundy's Lane during the War of 1812. Laura Secord and her family did not settle in Nelson Township but conveyed the lot to settler John Beaupre in 1810. (Enjoy my novel that tells about Laura, *Laura Secord Discovered*.) Over the next one hundred years the property passed through about fifteen different families. In 1912, it was purchased by William Delos Flatt and Cyrus Albert Birge. The site was used as a park by local residents for leisure pursuits such as swimming, boating and fishing, while the rest of the property continued in use as a fruit farm.

Following the death of the prominent Hamilton industrialist Cyrus Birge in 1929, his daughter Edythe MacKay used her inheritance to replace the old Zimmerman farmhouse on her Shore Acres Estate. It was built by local contractors and craftsmen with the finest imported and local materials. The mansion stands on a fourteen acre property on the Burlington waterfront. This three storey, 11,000 square-foot mansion has original hardwood floors throughout, seven working fireplaces, many original fixtures and decorations with a relaxed charm and intimacy.

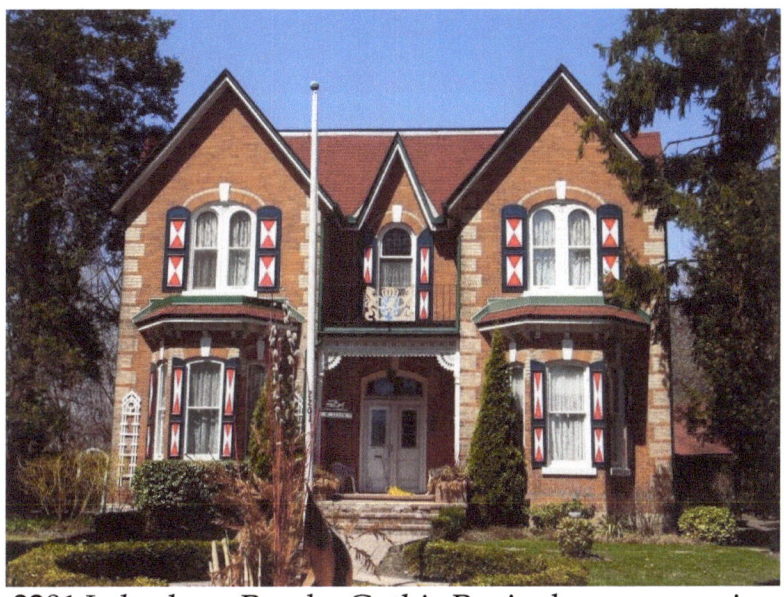

2201 Lakeshore Road – Gothic Revival, corner quoins

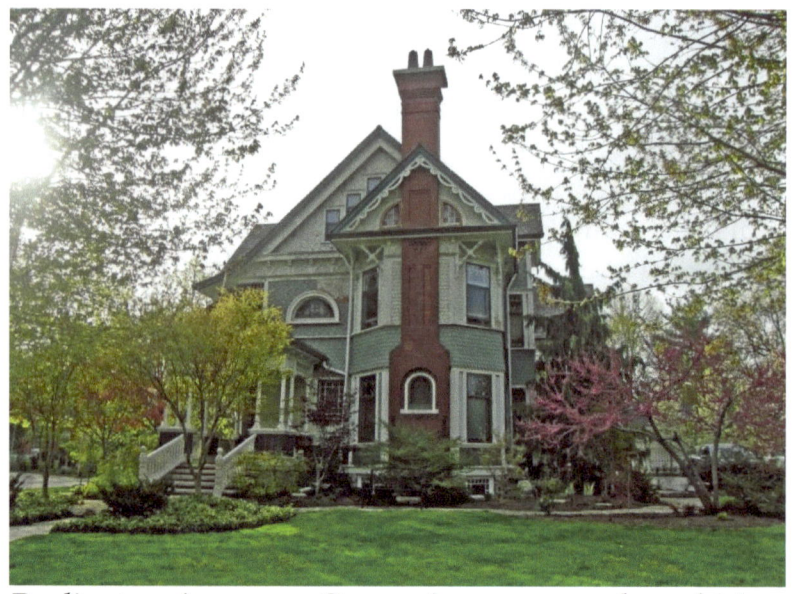

Burlington Avenue – Queen Anne – verge board trim, decorative brickwork below cornice, half-moon window, fish scale pattern on tower

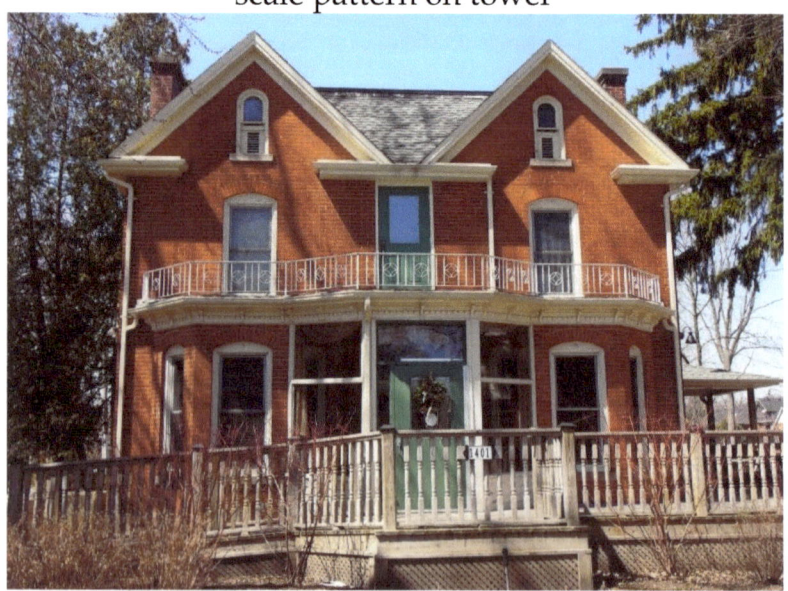

1401 Ontario Street – Gothic Revival – cornice return on gables, full verandah on second floor

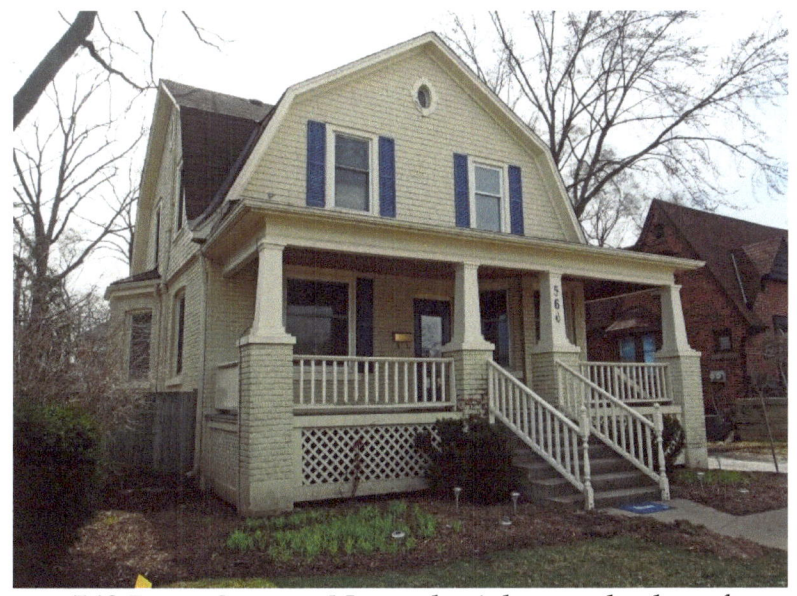
560 Brant Street – Neo-colonial – gambrel roof

Guelph, Ontario – My Top 7 Picks

Guelph, known as "The Royal City, is located 100 kilometers (62 miles) west of downtown Toronto at the intersection of Highways 6 and 7. Guelph was founded on St. George's Day, April 23, 1827, the feast day of the patron saint of England. The town was named to honor Britain's royal family, the Hanoverians who were descended from the Guelfs, the ancestral family of George IV, the reigning British monarch.

John Galt designed the town to resemble a European city CENTRE with squares, broad main streets and narrow side streets, resulting in a variety of block sizes and shapes. The street plan was designed to resemble a lady's fan with many of the streets forming triangles (the segments of the fan).

The first cable TV system began in Guelph with their first broadcast being the coronation of Queen Elizabeth II in 1953. The Speed and Eramosa Rivers flow through the city.

Riverside Park is an 80-acre park built around a portion of the Speed River that runs through Guelph. The park opened in 1905.

The Ontario Agricultural College, the oldest part of the University of Guelph, began in 1873 as an associate agricultural college of the University of Toronto. The Government of Ontario purchased 550 acres of land from F. W. Stone to build the college. In 1964, the Ontario Agricultural College, Ontario Veterinary College and Macdonald Institute combined to become the University of Guelph and Wellington College.

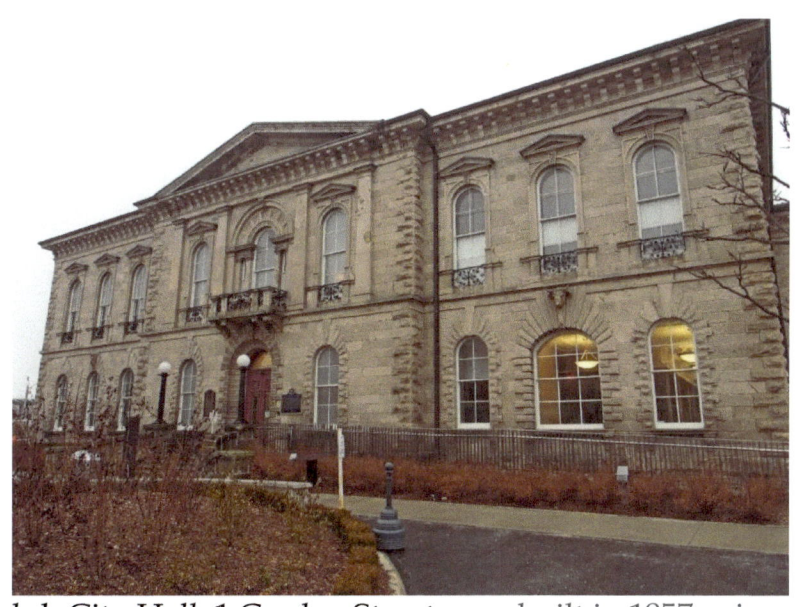

Guelph City Hall, 1 Carden Street, was built in 1857 using locally quarried Lockport Dolomite, and was fashioned in the Renaissance Revival style. When the building opened in 1857, Guelph had 4,500 residents. Pediment, cornice brackets, corner quoins – Guelph Book 1

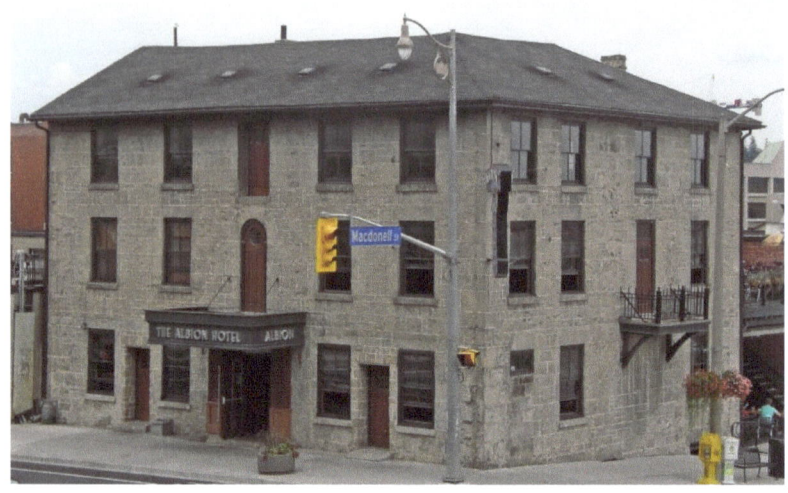

The building was constructed about 1867 of limestone from local quarries, and its structure is supported from the basement by 18-inch timbers. During the late nineteenth century, The Albion Hotel, along with twenty other hotels in the area, served the needs of farmers coming into town for the weekly market and the Provincial Fair in front of City Hall. – Guelph Book 1

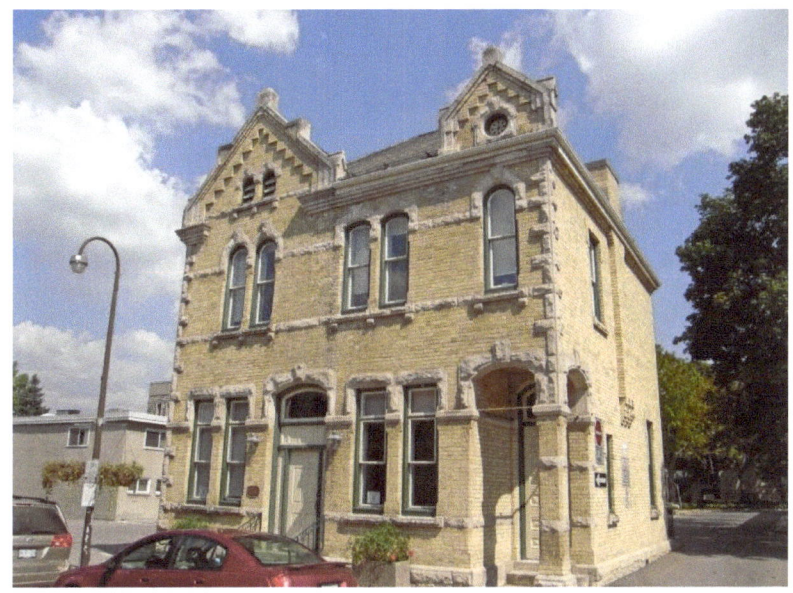

Douglas Street - Crown Attorney's Office – 1885 - corner quoins, banding, arched window hoods with keystones – Guelph Book 1

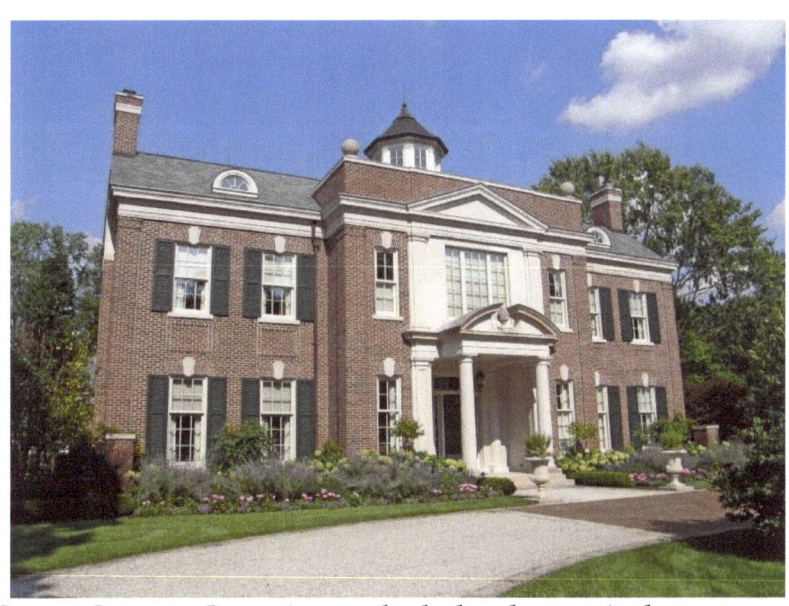

21 Stuart Street - Georgian style, belvedere, window voussoirs with keystones, portico – Guelph Book 1

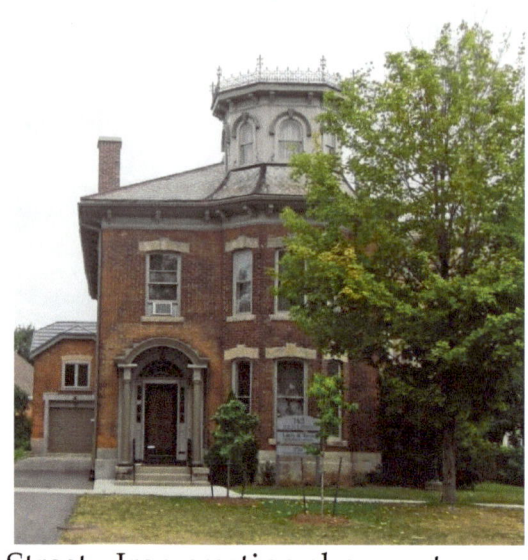

143 Norfolk Street - Iron cresting above octagonal belvedere – Guelph Book 2

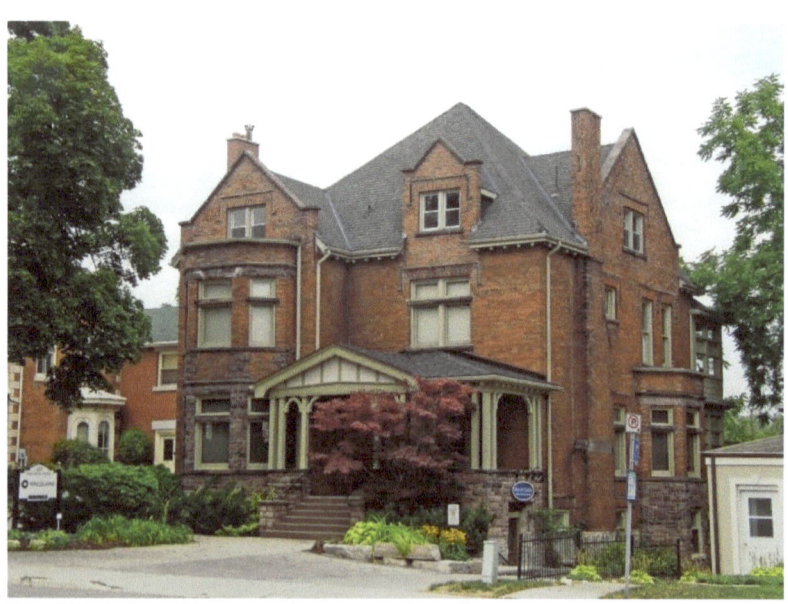

Red brick – Queen Anne style, three-storey tower, bay window on side, pediment above verandah – Guelph Book 2

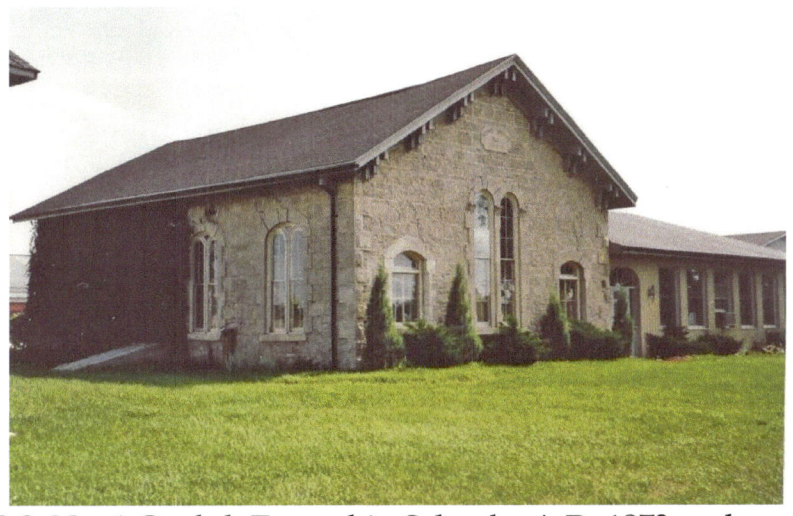

S.S. No. 1 Guelph Township School – A.D. 1873 - where I attended Grades 1 to 6 from 1957-63 - Limestone, paired cornice brackets – Guelph Book 2

Ayr, Ontario – My Best 5 Picks

Ayr is located south of Kitchener and west of Cambridge, and south of Highway 401.

In 1824, Abel Mudge built a saw mill and flour mill at the junction of Cedar Creek and the Nith River. This was the first of three settlements, Jedburgh in the east (Main Street), Nithvale in the west (Piper Street) and Mudge's Mill in the center (Stanley/Northumberland Streets) in what is today the Village of Ayr.

Jedburgh began in 1832 when John Hall, a young immigrant from Jedburgh, Scotland, purchased a 75-acre parcel of land that included the area now flooded by Jedburgh Dam. By 1850 Hall had developed several industries, including a flour mill, sawmill and distillery with water power provided by the damming of Cedar Creek. At the same time a smaller settlement, Nithvale, was founded to the west of Mudge's Mill where a small sawmill opened along the Nith River.

In 1840 when Robert Wyllie established a post office it was given the name "Ayr", a name influenced by the large number of former Ayrshire, Scotland immigrants who were drawn to Canada by promises of inexpensive, fertile land.

In 1846–47 Daniel Manley's mill was built, William Baker's store was established and John Watson's foundry constructed with Watson's Dam its power reservoir. These three key businesses played large roles in Ayr's early success as did the coming of the Credit Valley Railway in 1879. James Somerville began the first Ayr newspaper in 1854.

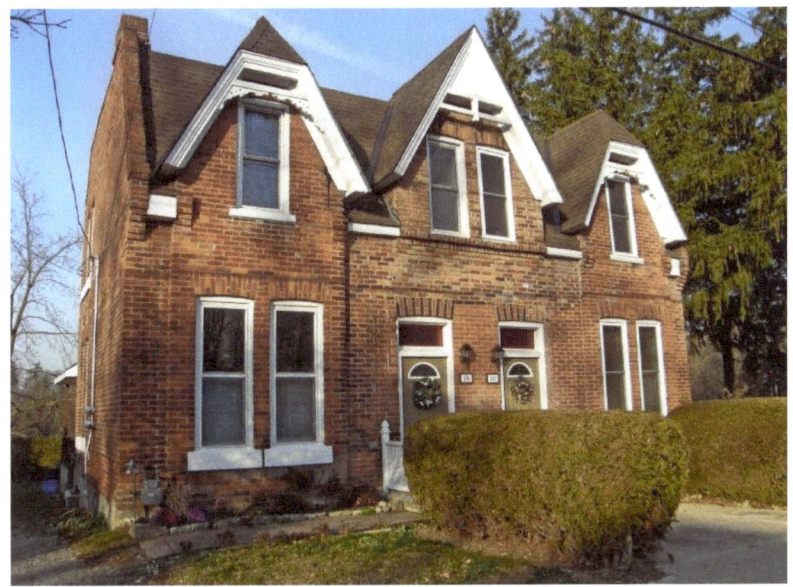

#190 and #192 - Triple-gable Gothic Revival style

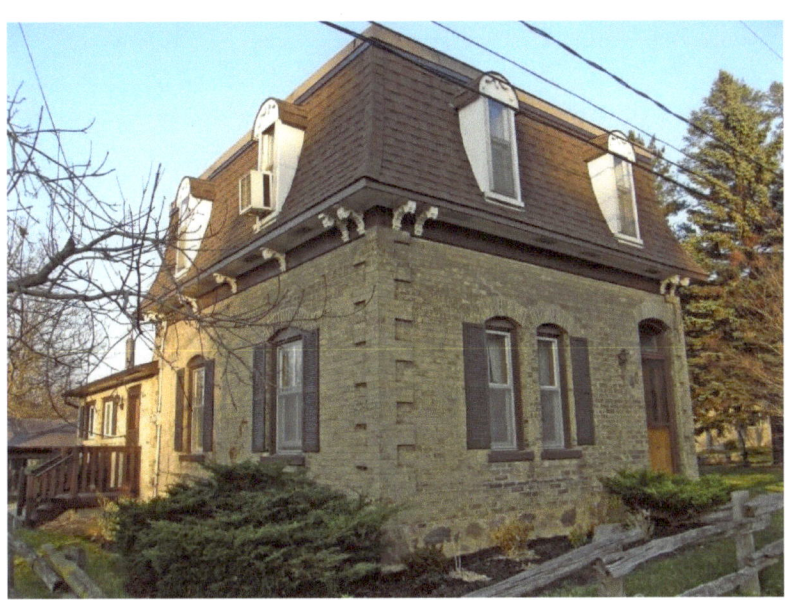

40 McDonald Street – Second Empire style, mansard roof with dormers, yellow brick, cornice brackets, corner quoins

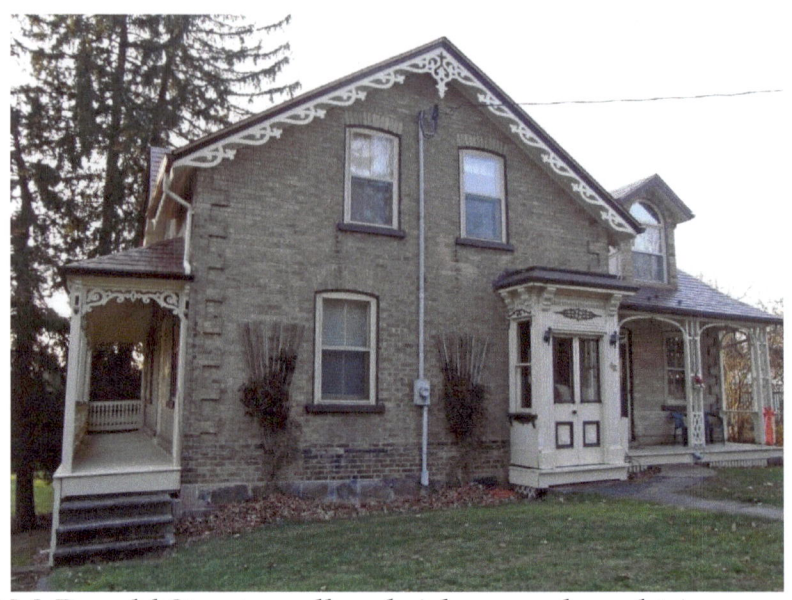

42 McDonald Street – yellow brick, verge board trim, corner quoins

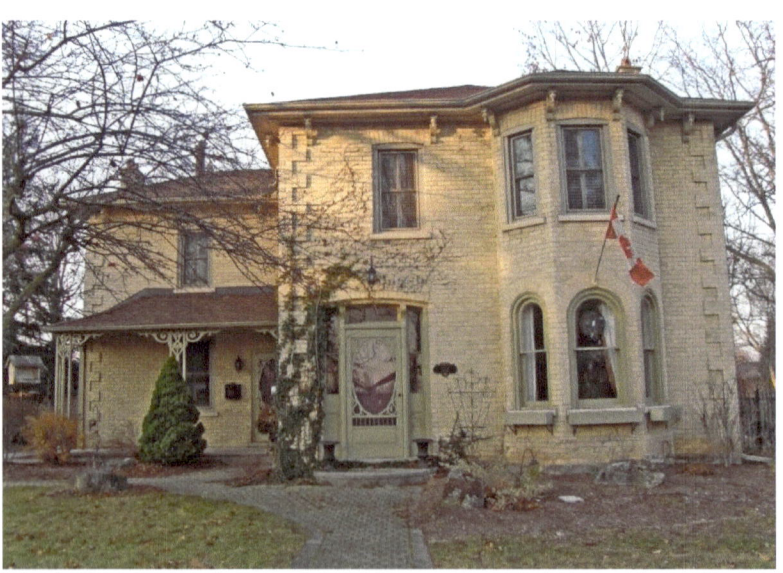

102 Main Street – Italianate – hip roof, yellow brick, two-storey bay window, corner quoins, cornice brackets

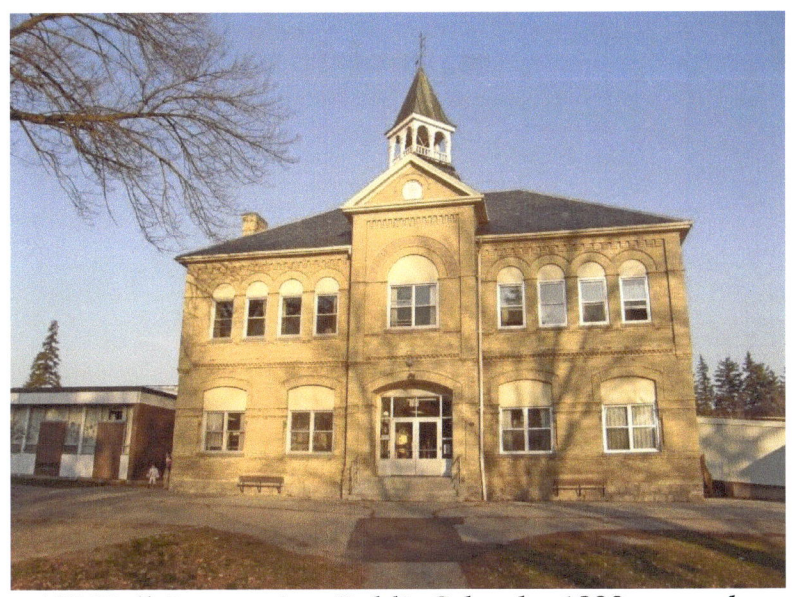

105 Hall Street - Ayr Public School – 1890 – cupola, Romanesque style window arches, dentil molding

Peterborough, Ontario – My Top 7 Picks

Peterborough is a city on the Otonabee River in central Ontario, 125 kilometers (78 miles) northeast of Toronto. Peterborough's nickname of "The Electric City" underscores the historical and present day importance of technology and manufacturing as an economic base of the city which has operations from large multi-national companies such as Seimans, Rolls Royce, and General Electric. Peterborough is known as the gateway to the Kawarthas, "cottage country", a large recreational region of the province. In 1818, Adam Scott settled on the west shore of the Otonabee River and the following year he began construction of a sawmill and gristmill, establishing the area as Scott's Plains. The mill was located at the foot of present-day King Street and was powered by water from Jackson Creek.

The year 1825 marked the arrival of 1,878 Irish immigrants from the city of Cork, a British Parliament experimental emigration plan to transport poor Irish families to Upper Canada. The scheme was managed by Peter Robinson, a politician in York (present-day Toronto). Scott's Plains was renamed Peterborough in his honor. The Irish emigrated from the Emerald Isle to escape over-crowding, poverty, political unrest, religious tensions, disease and the potato famine. By 1851 almost half of the town of Peterborough claimed Irish ancestry. They cleared the land in the rolling hills of the Peterborough countryside.

In 1845, Sandford Fleming, inventor of Standard Time and designer of Canada's first postage stamp, moved to the city to live with Dr. John Hutchison and his family, staying until 1847. Dr. John Hutchison was one of Peterborough's first resident doctors.

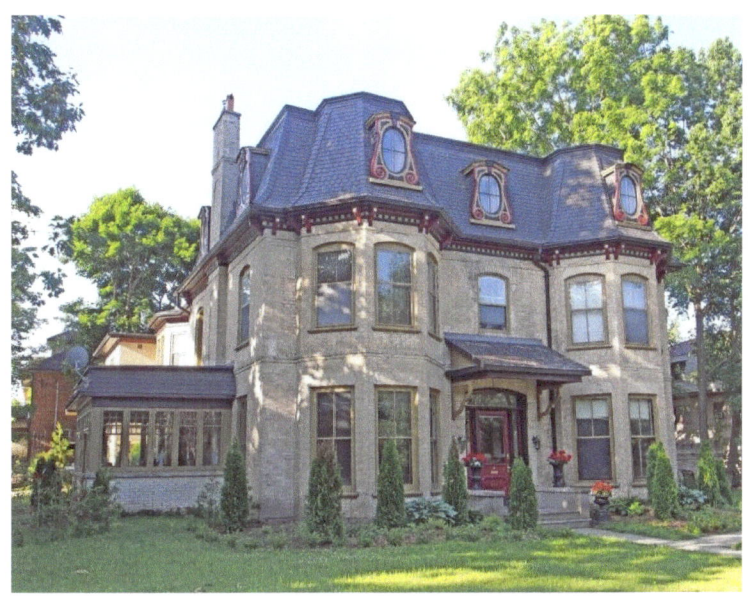

359 Downie Street – Second Empire style, mansard roof, window hoods, 2 storey bay windows – Peterborough Book 1

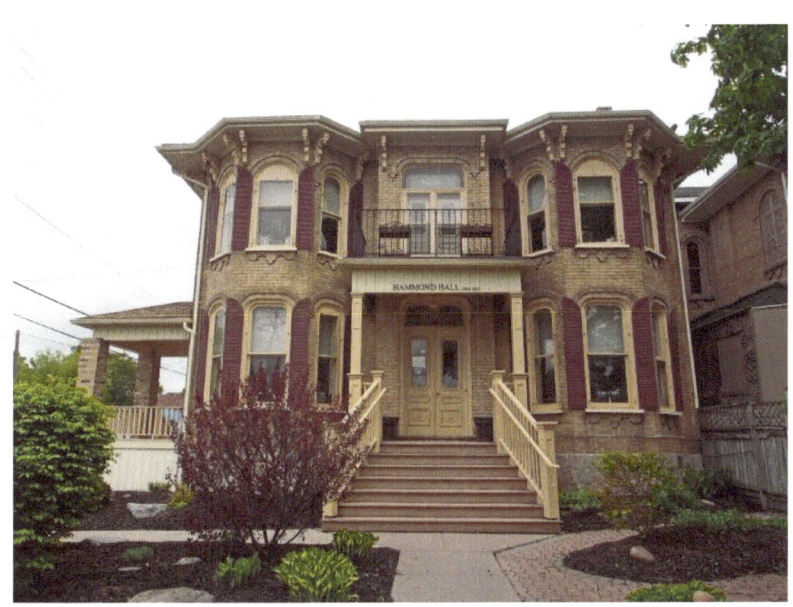

232 Brock Street – Italianate, cornice brackets, two-storey bay windows, second floor balcony – Peterborough Book 2

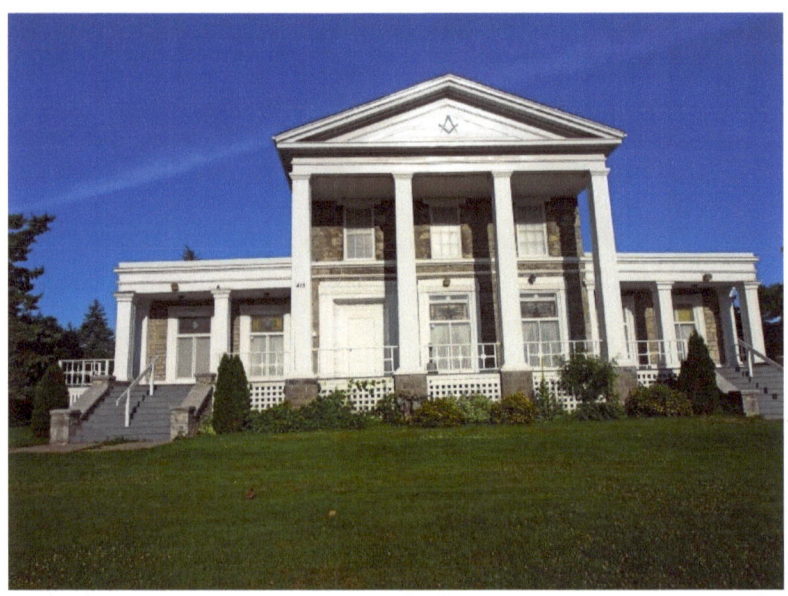

413 Rubidge Street - Grover Nichols House – an outstanding example of Greek Revival architecture, modified in the Palladian manner, it was begun about 1847 by P.M. Grover, a well-to-do local merchant. The square pillars are a Classical Greek feature. The local Masonic Lodge held its meetings here from 1849 to 1853 and the Masons purchased this imposing house in 1950. – Peterborough Book 2

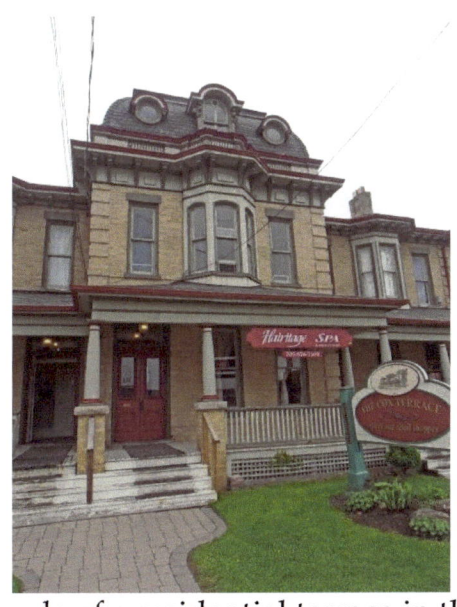

An elegant example of a residential terrace in the Second Empire style, Cox Terrace, 332-344 Rubidge Street, was constructed in 1884 during a time of prosperity and rapid urban growth in Peterborough. In this row of houses, inspired by British models, seven dwellings are skillfully unified behind one façade with three projecting pavilions. Mansard roofs, dormers, and oriel windows give life to the distinctive design. The terrace was built for Sir George Cox, one of the wealthiest and most influential Canadian businessmen of the period. – Peterborough Book 2

George Street corner – Second Empire style, window hoods on dormers, banding on top floor; cornice brackets, dentil moulding, pilasters on 2nd floor; Romanesque style window voussoirs and keystones on ground level – Peterborough Book 2

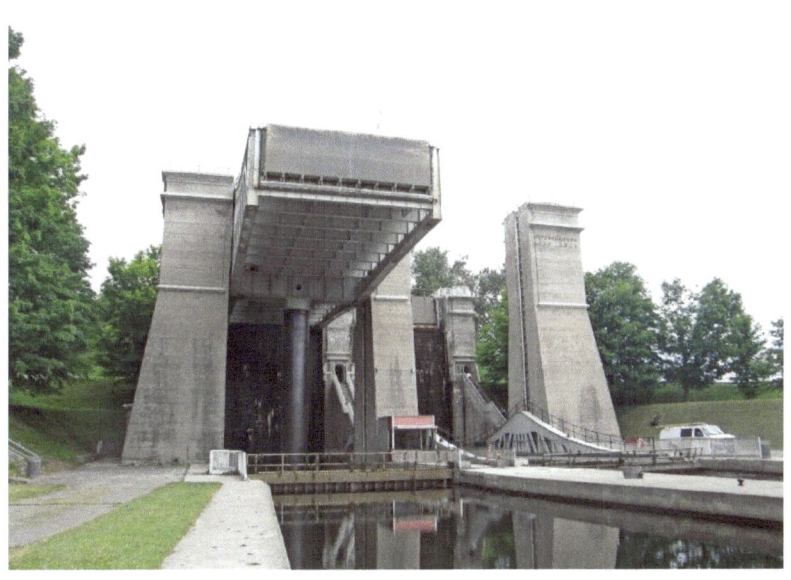

The Peterborough Lift Lock was completed on July 9, 1904. It was the first lock to be built out of concrete and at the time was the largest structure built in the world with unreinforced concrete. It is a boat lift located on the Trent Canal in the city of Peterborough and is Lock 21 on the Trent-Severn Waterway. The dual lifts are the highest hydraulic boat lifts in the world, with a lift of 19.8 m (65 feet). – Peterborough Book 3

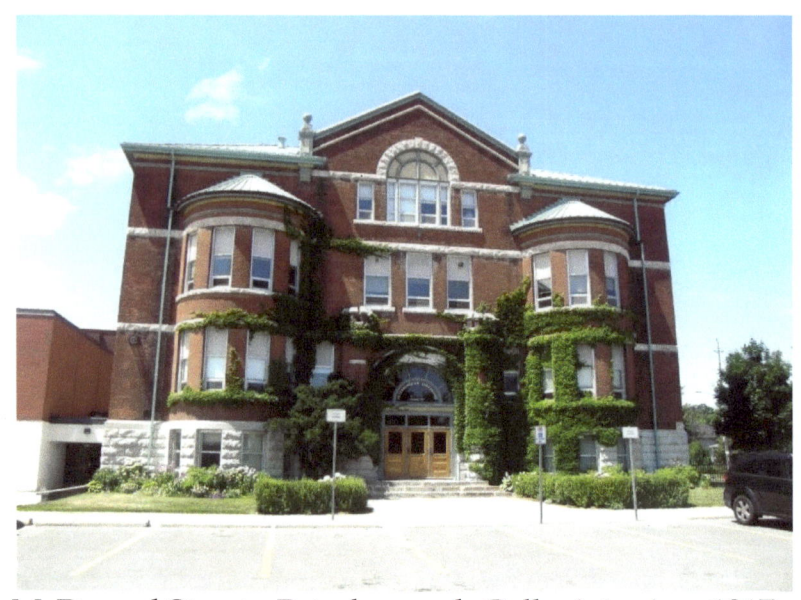

McDonnel Street - Peterborough Collegiate circa 1917 – Romanesque Revival architecture – Peterborough Book 3

Orangeville, Ontario – My Top 6 Picks

Orange Lawrence helped to develop the community. He bought 300 acres, laid out the southeast part of town, bought Grigg's Mill, opened a general store and a tavern, built a second mill, founded the first school, and became the village's first postmaster in 1847. He left a strong mark on the community which took the appropriate name of Orangeville.

Immigrants from Ireland and other parts of the British Isles and Canada West came throughout the 1840s and 1850s with some establishing successful mixed farms while others settled in the village and became the landowners, merchants, and tradesmen whose needs lead to the development of good transportation routes.

It was the foresight of Orange Lawrence and Jesse Ketchum that had large sections of land on either side of the main street laid out for both commercial and residential building lots. The south side followed Mill Creek while a regular grid pattern was determined for the streets on the north side from First to Fifth Streets both east and west and north to Fifth Avenue, with a wide main street called Broadway. This 30-metre (100-foot) avenue was not typical of Ontario towns of the time, but has proven to be very valuable over the years. In 1875 the Town Hall was constructed, and in 1887 the first telephone exchange was established, but it wasn't until 1916 that electricity came to the town.

The old town of Orangeville is still alive today. Some of the buildings on Broadway have been demolished; others have been renovated, while others remain as they were when they were built 120 years ago.

There are hundreds of old buildings in Orangeville which have retained their 1800s architectural styles and character. The first Orangeville book covers the beginnings of Orangeville with pictures from the south side of town, and buildings on Broadway. An appendix is included to describe architectural styles and terms which are referred to throughout the book. The second book covers buildings to the north of the town, as well as pictures taken in surrounding villages of Laurel, Caledon Village and Mono Centre.

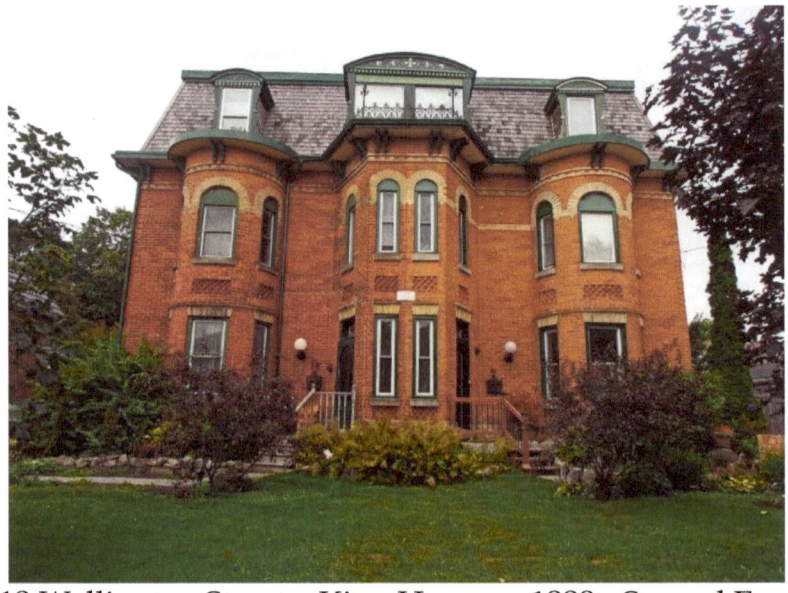

16-18 Wellington Street – King House c. 1888 - Second Empire style – large brick house, mansard roof, ornamental ironwork – Orangeville Book 1

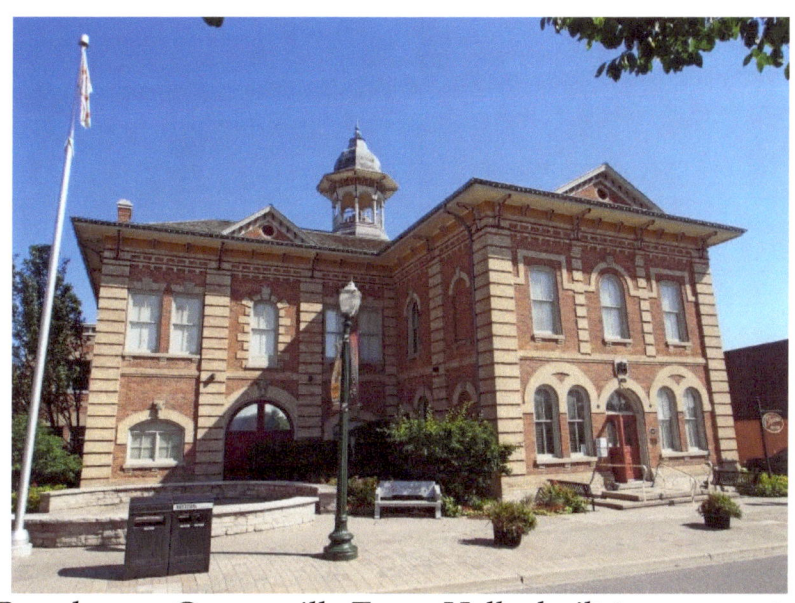

87 Broadway – Orangeville Town Hall – built to serve as town hall, municipal offices, market area, opera house – c. 1875 - Italianate architecture with projecting roof eaves, paired cornice brackets, pedimented roof line, and use of contrasting brick colors – the cupola is a prominent feature – Orangeville Book 2

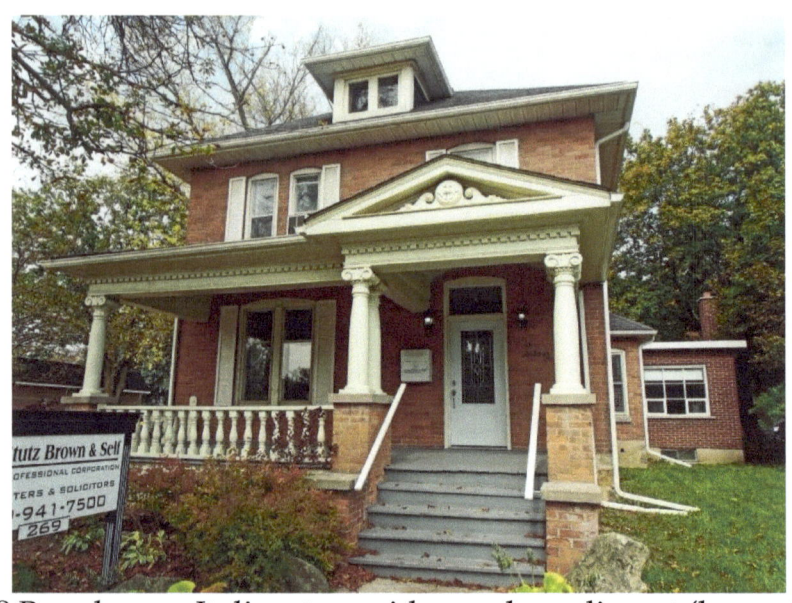

269 Broadway – Italianate – wide porch, pediment (low gable over the door) with decorated tympanum, Ionic capitals on the pillars – Orangeville Book 2

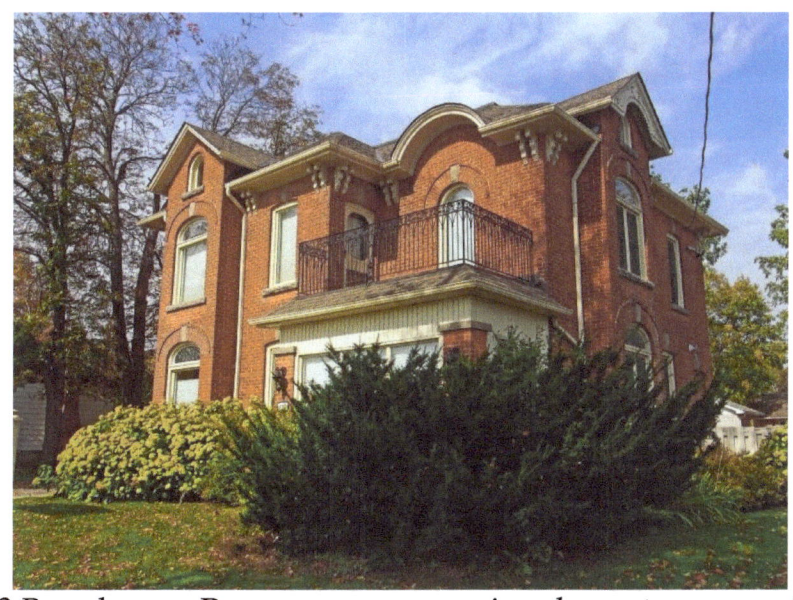

283 Broadway – Romanesque – massive shape, tower on side and front, large arches over windows – Orangeville Book 2

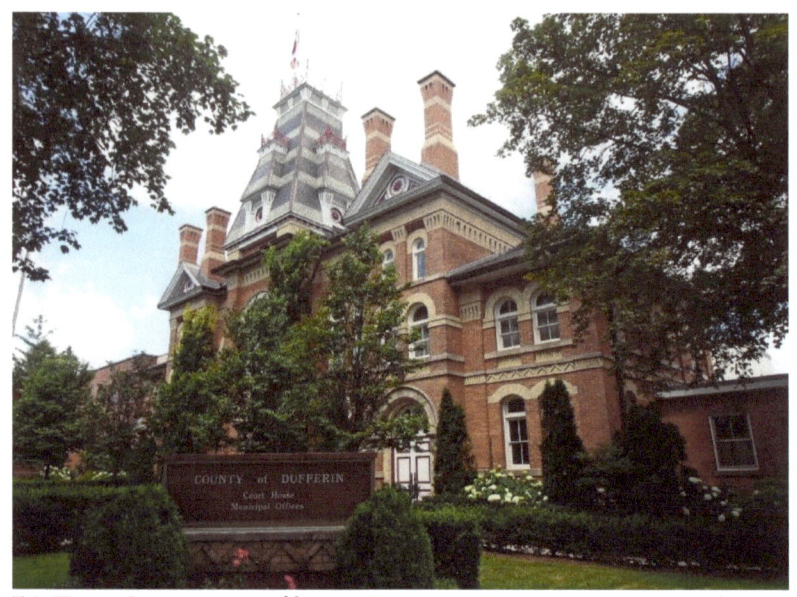

51 Zina Street - Dufferin County Court House - Classic Revival style built in 1880 with three towers that project from the façade, the center one most prominent; buff brick for decorative window hoods, bands, panels; cornice and capitals on red brick pilasters; projecting gable ends with triangular pediments and decorated tympanums – Orangeville Book 3

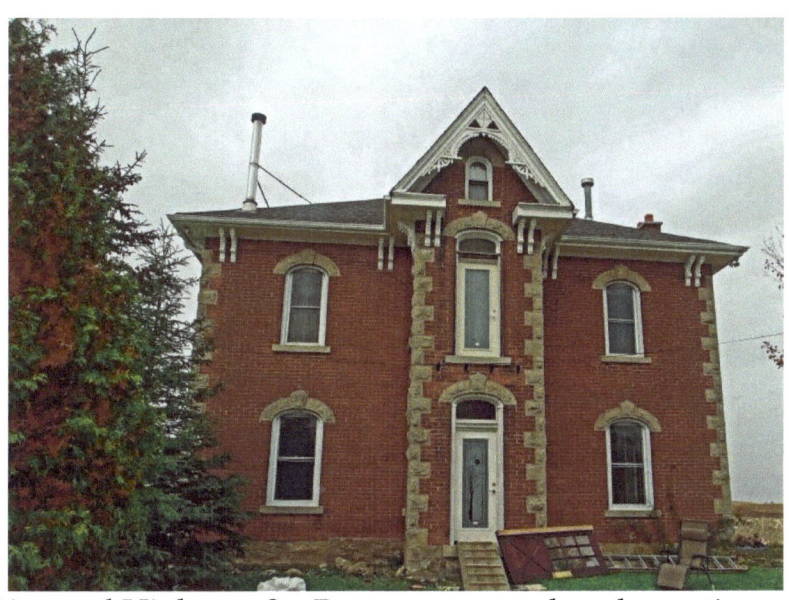

1st Line and Highway 9 – Romanesque style – decorative verge board on gable, paired cornice brackets, quoining on center tower and corners, rounded window voussoirs with keystones – Orangeville Book 3

Southampton, Ontario – My Top 6 Picks

Southampton is located on Lake Huron at the mouth of the Saugeen River. It is located south of Sauble Beach and north of Port Elgin.

In the spring of 1848, Captain John Spence, a native of the Orkney Islands in northern Scotland, arrived at the mouth of the Saugeen River after an overland journey on foot from Owen Sound. He was impressed with the potential of the area, returned to Owen Sound for provisions and the following year built a cabin near the mouth of the river, becoming Southampton's first permanent settler. His wife and family joined him in 1850. He bought the fishing schooner "Sea Gull" for coastal trade along the shores of Lake Huron.

It is quiet and peaceful on Southampton's beach, a four-kilometer-long stretch of shore. The wooden Long Dock extends towards Chantry Island with its lighthouse in view offshore.

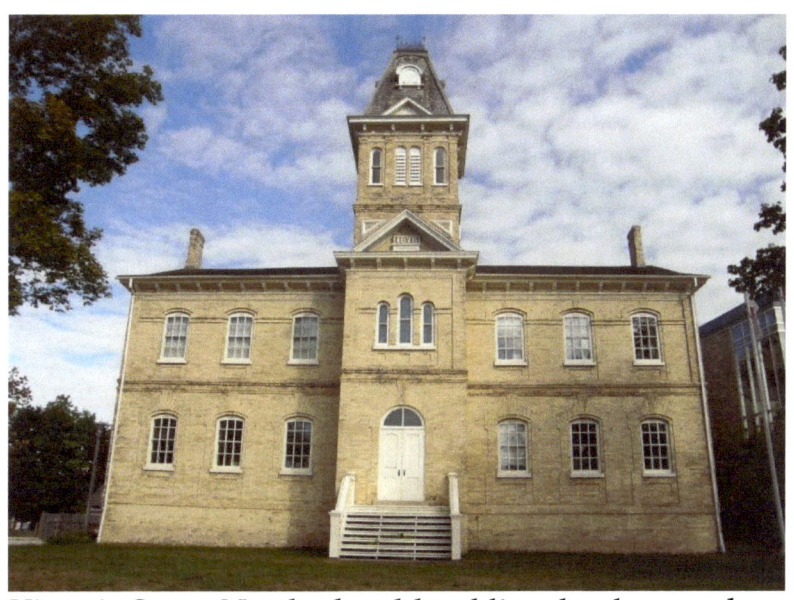

33 Victoria Street North, the old public school – now houses the Bruce County Museum and Cultural Centre - 1878 – yellow brick – Italianate style with Two-and-a-half storey tower-like bay with two-storey tower above, iron cresting on top

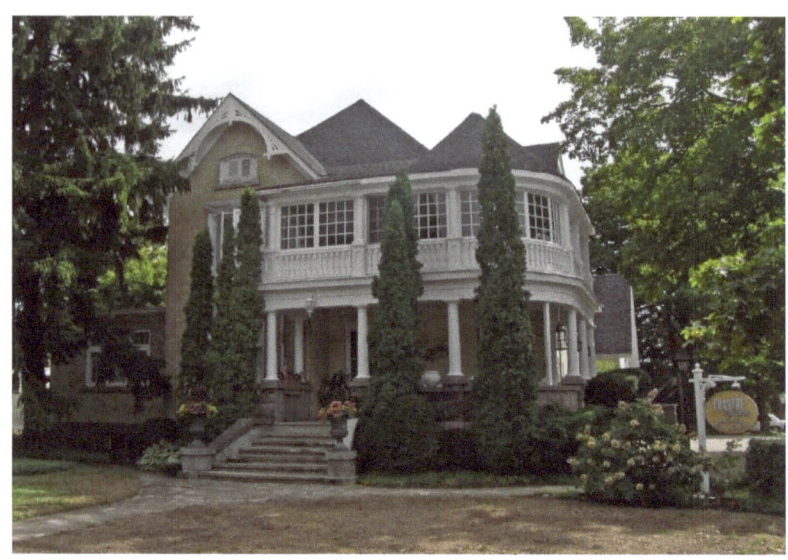

107 High Street - Chantry Breezes Bed and Breakfast - George E. Smith, Customs Officer - c. 1907 – Queen Anne style - spacious wrap-around porches, patios, flower gardens, mature trees, one block from white sand beaches of Lake Huron, has seven tastefully decorated bedrooms featuring antiques, historic charm and en-suite bathrooms

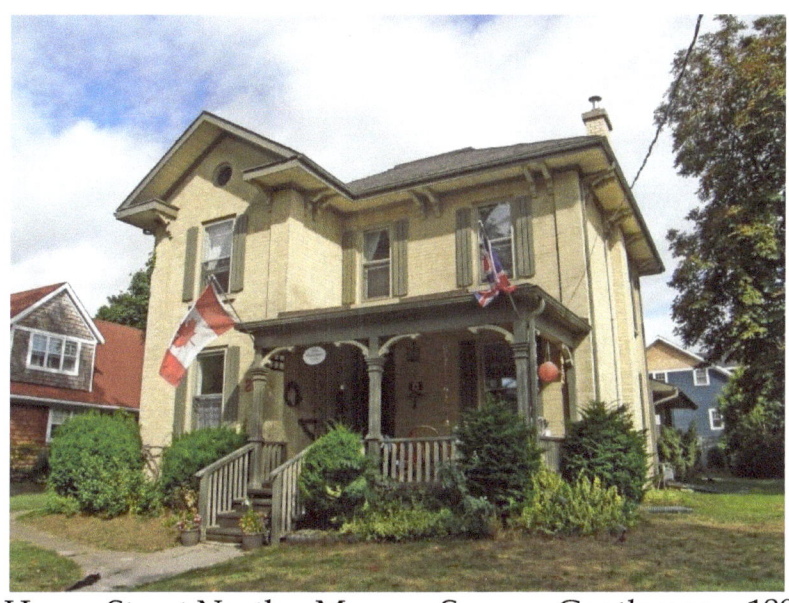

25 Huron Street North – Magnus Spence, Gentleman – 1896 - Italianate style with two-and-a-half storey tower-like bay with projecting eaves, paired cornice brackets, cornice return on gable

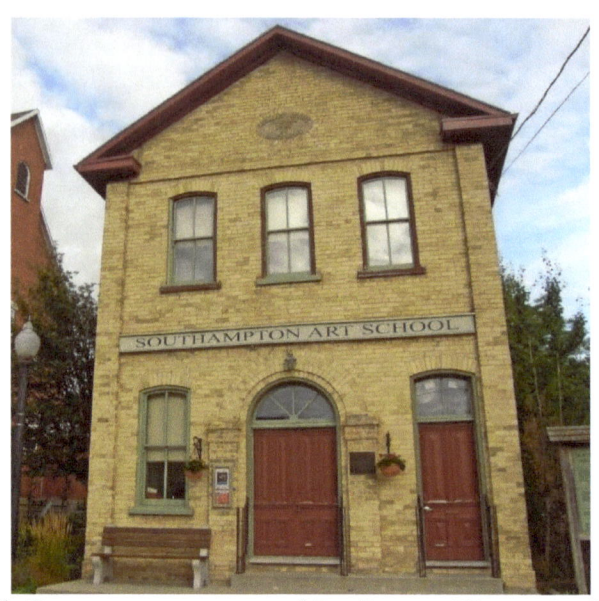

201 High Street – constructed by James Howe in 1887 as a private library and used as a Mechanics Institute until 1892; from 1896 to 1955 it housed a public library – yellow brick, Gothic Revival style, cornice return on gable - In 1957 it became the Southampton Art School.

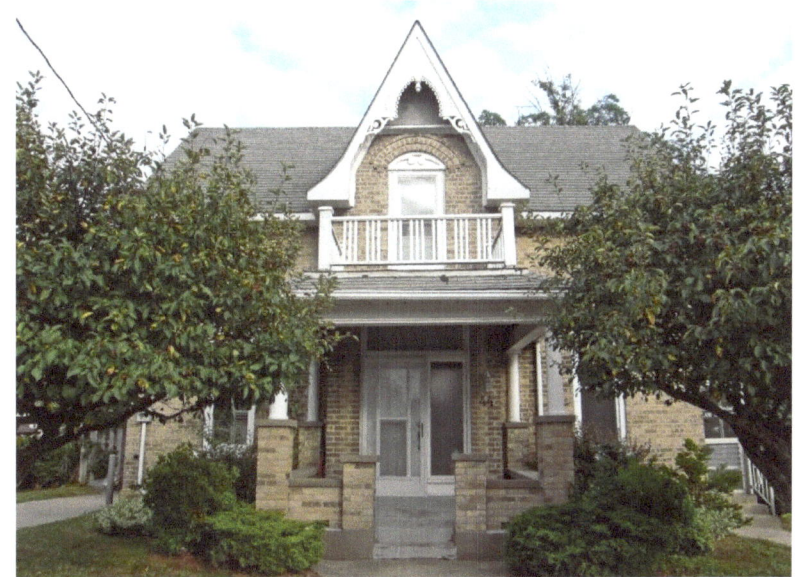

#44 – Gothic Revival – one-and-a-half storeys, second floor balcony, verge board trim on gable

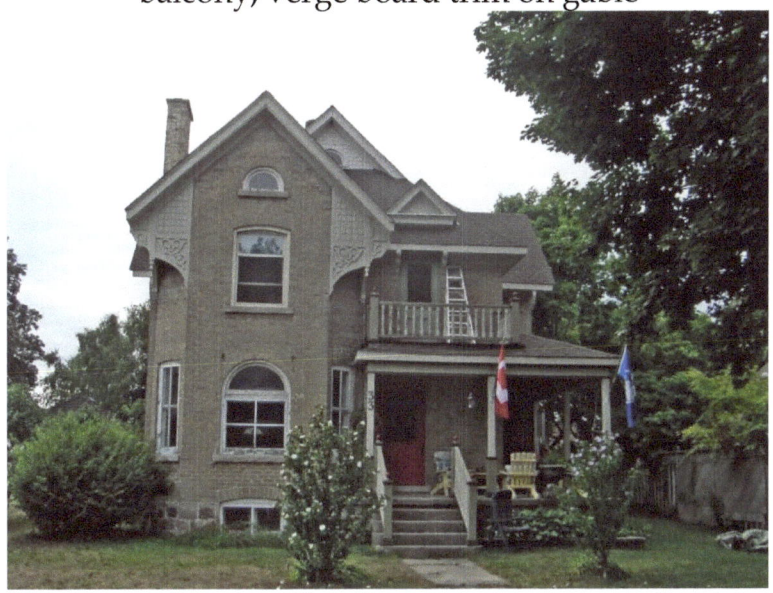

33 Albert Street South – The Customs Agent once lived in this house, which was built in 1902 by the Bowman Family who were owners of the local tannery. Gothic Revival/Queen Anne style – large fretwork pieces resembling brackets

www.ingramcontent.com/pod-product-compliance
Lightning Source LLC
Chambersburg PA
CBHW041102180526
45172CB00001B/70